The Stone Puzzle
of Rosslyn Chapel

Frontier Publishing

Adventures Unlimited Press

The Stone Puzzle of Rosslyn Chapel

The Truth behind its Templar and Masonic Secrets

Philip Coppens

Second, completely revised edition

Frontier Publishing
Adventures Unlimited Press

Frontier Publishing
PO Box 48
1600 AA Enkhuizen
the Netherlands
Tel. +31-(0)228-324076
Fax +31-(0)228-312081
fp@fsf.nl
http://www.fsf.nl

Contents

1. ACKNOWLEDGEMENTS

I was introduced to the reality of Rosslyn Chapel by John and Joy Millar, who organised a conference in the nearby coastal village of Gullane. A heartfelt thanks is required for bringing this "stone puzzle" into my life. Little did I know, when this quest began, that I would end up living nearby.

Young Charles Tulley made for a memorable visit on 2nd January by getting me to chase him in, out and even on top of the chapel. It allowed for a unique experience, which I hope, when he grows up, he will undergo, by revisiting it in a calmer frame of mind. My heartfelt thanks go as well to Caroline Tulley for introducing me to the region and for bringing Rosslyn Chapel more into the centre of my life, which was pivotal in making this guide - and for being around when the idea of writing it germinated.

Apart from those mentioned above, there are many people to thank for their contributions during the research phase of this project: Niven Sinclair for the St. Duthacs church on Orkney; Rory Sinclair for information on the east wall "chairs"; Judith Fisken for valuable information on the rededication; Geoff Potts for his insights into modern-day Rosslyn Castle and providing photographs of the outside of the chapel; André Douzet for his information on St. Victor in Marseille; Steve Sweeney-Turner and Michael Apter for their information on Wallace Cave and Roslin Glen in general; Francine Bernier for the information on the bag-pipe playing figures of French cathedrals; John Ritchie for a lot of things, including a guided tour of Temple, as well as being a point of sane contact in the often mad world of Rosslyn.

Herman Hegge for putting up with my suggestions over the past seven years, and for actually still being willing to listen to them and bringing so many of them about.
Gay Roberts, for again being an excellent editor. Apart from making sure the text is readable, her knowledge and remarks are often fresh insights and make the editing experience a joy to live through.

Finally, to William St. Clair for building the chapel. I am sure he could have written a better guide than this one... but then he never did.

2. INTRODUCTION

Recently, Rosslyn Chapel has been described as Britain's answer to Rennes-le-Chateau, a small French village in the Languedoc that is the focus of ever-continuing mystery. Nevertheless, at the heart of it seems to be no genuine mystery. Like it French counterpart, Rosslyn Chapel has become the dumping ground for various sacred treasures - as if an earthquake somehow shifted all sacred relics towards Roslin valley.

Nevertheless, Rosslyn Chapel is a treasure, both for the mystic traveller and the ordinary tourist. The French organisation Michelin, publisher of *The Green Guide* series, has awarded Rosslyn Chapel two stars ("worth a detour") and the Apprentice Pillar inside the Chapel three stars ("worth a journey"), the highest classification in their grading system. This it attains on its historical and architectural merits. But over the past two decades, the chapel has attained an even higher, almost mythical classification. The central question posed is this: does Rosslyn Chapel hold a secret that could radically re-interpret accepted history?

The nature of the secret is different from one publication to the next. To some, the secret is that Rosslyn Chapel is a "Grail chapel". To others, it is the hiding place of a religious treasure, which for some means the head of Jesus Christ, for others a piece of the Cross on which Jesus was crucified, or the Grail cup or scrolls detailing a history of Christianity that is radically different from the currently accepted one. As an added bonus, the chapel is also supposed to contains evidence that America may have been discovered one hundred years before Columbus. In the end, it might almost be forgotten that the chapel is also a site of pilgrimage for freemasons from all over the world - American tourists often visit the chapel on their way to or from Edinburgh airport, their luggage sitting in the cab, waiting outside during their visit. In short, this small chapel has attained more mystery than Scotland's capital Edinburgh.

The chapel is some five miles South of Edinburgh, in the small village of Roslin. Separated from the Scottish capital by the City Bypass, it is unlikely to be claimed in the near future by that insatiable desire for expansion that holds all modern Western cities in its grip.

In the 1990s, Roslin itself acquired international and lasting media fame when the Roslin Institute cloned the first animal, "Dolly the Sheep". It is, however, only the most recent claim to fame for this small village. For a very long time, the area of Roslin was owned by the Sinclairs, one of the oldest and most prominent Scottish families. In the 15th Century, they built Rosslyn Chapel, as well as nearby Rosslyn Castle. Two centuries ago, when the chapel's doors could most often be found locked, the family maintained its status when the heir was chosen as first

grand master of Scottish Freemasonry. This little church has captured the imagination of many - sometimes causing people to leave all reason and logic outside its walls. Some people have chained themselves inside, others have used power tools to penetrate parts of the chapel where they believe treasure is hidden. So far, dynamite has not been used, but who knows what the future will bring? Some more conspiratorially minded researchers have even argued that it was "no coincidence" that mankind's first cloned animal came from the laboratories at Roslin, rather than anywhere else in the world. It underlines the cultural role the chapel has assumed: a small chapel that seems to hold the answer to all the big questions in the universe.

The chapel is a small gem. Niven Sinclair has described how different it is from many other chapels and churches: *"If you go to St Paul's Cathedral, you can take it in in a single visit. If you go to Rosslyn Chapel you can't. I must count the number of times I've been there in hundreds, and every time I go I find something new. This is the beauty of the place."* Others have noticed how remarkably "un-Christian" the church is. Some have even decided not to attend mass there, once they have come to the conclusion that the church was not Christian in concept at all. Nevertheless, weekly services are held inside there.

It was on an early Monday morning in October 1998 that I entered the chapel for the first time. After only four hours sleep the previous night, having engaged in discussions with John Ritchie, press secretary for the modern Scottish Knights Templar, physically I was somewhat unprepared for the mental ecstasy of finally being there. The year before, the full Grand Council of John's order had taken part in a film-shoot by the Arts and Entertainment's *Ancient Mysteries Series*, with the help of the Rosslyn Chapel Trust at Rosslyn Chapel. They filmed the investiture of a knight into the Order. John now played "host" to our small group, which included the authors Lynn Picknett, Clive Prince and Alan Butler and his partner Kate.

By the time we arrived, the four hours of sleep had caught up with me and it was only after some time that I could free my thoughts from a headache, enough to admire both the interior and, with full wind-chill, the exterior of the chapel. Just like Professor Philip Davies, I felt this building was not like any chapel I had seen. It had nothing Christian about it.

It has been noted that children quite often go "mad" when inside the chapel; this is attributed by some to a strange energy going around it. But rather than any form of bizarre energy, the building has an "atmosphere"; it is a big play garden... or at least more so than a

Christian chapel. And no doubt it is the absence of Christianity that drives "the devil" into the children... On one occasion I spent more time chasing after a child, who had gone berserk, than I did chasing after any secret inside or outside the the chapel.

Around thirty thousand tourists visit the chapel each year. Royal visitors have included King George V and Queen Mary, who came in 1931, Queen Elizabeth and Prince Philip, who came in 1961, Princess Margaret, who came in 1988 and Prince Charles, who came in 1998. When Queen Victoria entered the building during one of her many visits to Scotland, she proposed its re-dedication as a place of worship.

Two of Scotland's best-known sons also visited the building - and fell in love with it. Both Sir Walter Scott and Robert Burns were freemasons and this might have stimulated them even more in singing the chapel's praise.

Sir Walter Scott spoke of the ancient Barons of Rosslyn who were buried in the chapel crypt in his famous poem, *"The Lay of the Last Minstrel"*. In 1812, he bought the small farmhouse of Cartley Hall, which he renamed Abottsford, on the banks of the Tweed, in the Scottish Borders. He had the ceiling of the Library moulded as a copy of the ceiling of Rosslyn Chapel.

In 1787, Robert Burns, who is recognised as the Poet Laureate of both Scotland and Masonry, visited the chapel with his friend, the artist Alexander Nasmyth, and insisted that he paint his portrait while at Rosslyn.

But despite the number of visitors, who come here, what was lacking was a guide for those, who wanted to know more about the history of the church and the various theories surrounding it. The chapel is said by many to be a stone puzzle of freemasonry, yet not a single guide tries to go beyond the layer of the obvious and look at the symbolic layer of the building. This layer does not stop at the outside walls of Rosslyn Chapel, but extends into the surrounding landscape, into the beautiful and wild Roslin Glenn - and beyond.

3. THE NAME ROSSLYN

Rosslyn, or Roslin, that is the question. Both spellings are accepted, as well as various others, which have been used in previous centuries. It is often claimed that the village was constructed to house the stoneworkers labouring on the construction of the chapel, but recent research does not support this suggestion.

Archaeologists believe that the village was founded in Pictish times (3rd Century AD). Some believe it was founded by Asterius, whose daughter Panthioria, a Pictish lady, married Donald I, who lived about 193 AD. At that time, Rosslyn was a great forest with deer, hinds, roe and other wild beasts.

A large labour-force was brought into the area to work on the chapel and the castle. With the resulting economic change in the region, in the 15th Century, Roslin became the third town of the Lothians, after nearby Edinburgh and Haddington, to the East. In 1456, while the chapel was slowly rising from the ground, the town was created a burgh. Its major industry at the time was mining, an industry dating back to the 12th Century.

According to Chambers' *Scottish Place Names*, the translation of the name is "morass at a pool", but if there was ever any evidence of either such feature in the landscape, there is none now. Forbes, in the 18th Century, believed the original name was Roskelyn, and felt it was Gaelic or Erse for a hill in a glen. Some believe the name is composed of "ros", meaning a ridge or promontory, and "lin", a waterfall. There is a site known now as "linn", which is at the end of the promontory (see description below). It is quite likely that this feature was indeed responsible for the origins of the name: the waterfall at the end of the promontory is a distinctive marker, set deep inside the valley, the place where the river turns backwards on its path, creating the peninsula on which the chapel is built, with the chapel itself above.

Certain authors have pointed out that the choice of the word "ros" for promontory in Gaelic seems an odd one. According to Knight and Lomas, in Scottish Gaelic, "ros" means ancient knowledge, and "linn" means generation. So Roslinn, they believe, might also mean: "ancient knowledge of the generations, or passed down the generations." Author Keith Laidler has pointed out that the name is similar to Rose-Line, the line of the rose. This is a popular name for the Paris Meridian, France's Zero Meridian until 1884 when the world agreed on a single global zero meridian set at Greenwich.

Author Andrew Sinclair believes the name comes from rose, making it Rosy Stream or Fall. This is possible, as the town closest to Roslin is called Rosewell, the well of Roses.

Some wonder whether the family who owned the land before the Sinclairs did, the de Rosceline, who came from France, have given their name to the place. Again, this seems possible - if not likely. As they brought that name with them from France, it seems unlikely they were named after the local feature of a waterfall at the end of the promontory. But as happens so often with placenames, one name has various levels of interpretation - and Rosslyn seems to be no different.

4. THE SINCLAIRS

According to several books and the theories put forward in them, including the world famous best-selling book *The Holy Blood and the Holy Grail*, the Sinclair family is part of the group whose members call themselves the "Rex Deus" families. This term describes a group of people who, it is claimed, have tried throughout the centuries to propel descendants of the Merovingian dynasty to the forefront of European politics - to re-instate kingship over a unified Europe. Fifteen hundred years ago, this dynasty ruled over large sections of France and members of the "Rex Deus" families are believed to possess the royal Merovingian blood within their veins.

What is a fact, rather than fiction or speculation, is that the Sinclairs are one of the most important Scottish families - or at least they were from the 14th till the 18th Century. Throughout Scotland's drive for independence, including the heroic efforts of Robert the Bruce in proclaiming Scottish independence, the family was one of the driving forces of this movement. As such, they have always had an affinity with that "quirk" that in essence turns ordinary though wealthy people into legends. For example, Sir Walter Scott described the twenty Sinclair knights buried in full armour in the vaults of Rosslyn Chapel as if they were *"everlasting Knights of the Grail, on sentry duty over the mysteries entrusted to their keeping"*.

4.1 Rex Deus

According to the Rex Deus mythology, the Sinclairs trace their ancestry in an unbroken line back to Rognvald the Mighty, the Earl of Møre, in Norway, near Trondheim. His second son, Rollo, invaded France and established his own personal fiefdom in Normandy. It was there that they received their name, for the name Sinclair is said to come indirectly from the hermit William St. Clare, or variously St. Clere, or St. Clair, from the Latin: Sanctus Clarus, "Holy Light". He lived near the town that is now called St. Clair sur l'Epte, northwest of Paris, and the French home of the family. Apparently he was scandalised by the loose morals of a lady and prophesied that she would come to a bad end. In return for this dire prediction, she had him murdered, by beheading. This harsh end was the reason for his depiction as a headless figure, holding his severed head in his hands.

The family's patron saint was St. Catherine of Alexandria, who was also beheaded. According to the legend, Catherine of Alexandria converted large numbers of Alexandrian inhabitants to Christianity, for which she was put to death. Her body was said to have been taken to

Mount Sinai, where some centuries later the now famous St. Catherine's Monastery was built.

The Rex Deus mythology does not end there. It states that King Charles the Simple of France acknowledged Rollo's status and gave him his daughter Giwelle as his wife. William the Conqueror, who seized the English throne in 1066, was a direct descendant of this Rollo.
The first St. Clair said to have arrived in Roslin was William the Seemly St. Clair. In 1057, he allegedly arrived with the knight Ladislaus Leslyn as escort to Princess Margaret, who was to marry King Malcolm of Canmore in Scotland. William was granted the land at Roslin and he also became the queen's cupbearer. A carving on the South wall of the chapel, often referred to as "two brothers on one horse", is said to show this scene: the knight Leslyn - the ancestor of the Leslie family - with the future queen riding pillion. The queen is carrying the symbolic representation of the relic known as the Holy Rood of Scotland, which was part of her dowry. This "Holy Rood" was believed to be a piece of the True Cross, on which Jesus Christ was crucified. The precious relic was contained within a golden cruciform casket, i.e. an actual Holy Grail, and some believe that this relic is hidden inside Rosslyn Chapel. One esoteric author, Lewis Spence, referred to Rosslyn Chapel as the Chapel of the Grail: *"Nothing can shake my conviction that Rosslyn was built according to the pattern of the Chapel of the Grail as pictured in Norman romance, and that William St. Clair had in his poet's mind a vision of the Chapel Perilous when he set hand to the work."*

4.2 Legendary vs. true origins

The first Sinclair said to be born in Scotland was one Henri de St. Clair, who accompanied Godfroi de Bouillon on his Crusade to the Holy Land in 1096. After the Crusaders' successful capture of Jerusalem, the site of the Temple of Solomon would see the foundation of a new order of Knights, the so-called Knights Templar, named after the Temple of Solomon, as it was on these ruins that their Priory was situated.

Popular legend has it that Hugues de Payens, the first grand master of the Templars, was actually married to Catherine de Saint-Clair, and that Hugues paid a visit to Rosslyn sometime around 1120, but no evidence has been put forward to back these allegations up. According to a recent biography, *Hugues de Payns, Chevalier Champenoise, Fondateur de l'Ordre des Templiers* (Troyes: editions de la Maison Boulanger, 1997) his wife was Elisabeth de Chappes. This statement is based on

local church charters, where the earliest mention of Elisabeth as his wife is in 1113. She is mentioned several times over the course of Hugues' lifetime, also during the period following his death, and finally with her own death in 1170.

Researchers who have studied Burke's Peerage, Cokayne's General Peerage, and Debrett's Peerage, have all stated that Guillaume de Saint-Clair, a Norman knight who was born in Normandy and accompanied his cousin Yolande de Dreux to Scotland for her marriage to King Alexander III, was the first of his family to become "laird" of Rosslyn. He obtained this title by marrying its heiress, Amecia de Roskelyn, around 1280 - a century and a half too late for the Templar Knight Hugues de Payens to have visited his Saint-Clair "in-laws" there - and a much later arrival on the scene than the "Rex Deus" mythology would have us believe.

Most of the "Rex Deus" researchers have blindly adopted the Sinclair family history that was compiled by Father Hay, a Sinclair biographer of the 17th Century. Father Hay was born in 1661, ordained at Chartres on 22nd September 1685 and died in 1736. Hay examined historical records and charters of the Sinclairs and in 1700, completed a three-volume study, parts of which were published in 1835 as *A geneologie of the Sainteclaires of Rosslyn*. His original manuscript is in the National Library of Scotland. Only twelve large paper copies and 108 small paper ones were printed. Since the papers on which Father Hay supposedly based his research were allegedly destroyed in a fire shortly afterwards, there was little possibility of double checking his version. However, in a guide to Rosslyn Chapel that was published at the end of the 19th Century, its author, a local Reverend Thompson, went out of his way to find supporting documentation.

Thompson was unable to find evidence that backed up the claims of Father Hay, who was himself a member of the Sinclair family. As Thompson diplomatically describes it: *"I must confess that I have been totally unable to reconcile the succession of names as given by Father Hay with those which appear in the 'Genealogical Chart' at Dysart House"*, this being where the archives of the Sinclair family are housed. Thompson came to the conclusion that the founding family of Rosslyn was not the Sinclair family, but a family called "of Roslyn" or "of Roskelyn", long before the Sinclairs arrived on the scene. *"For we find some charters witnessed by a Thomas de Roslyn; several others by a Roger de Roselyn: and another by Henry de Roskelyn."*

As mentioned, Father Hay, despite being named Richard Augustine Hay and being Canon of St. Geneviève in Paris and Prior of St. Piermont, was actually a Sinclair himself. So it seems that by virtue of his blood

ties, he could not help but succomb to some mythmaking and heroicising of his family origins. Several researchers believe that Hay was not the only one to do this and that, in recent years, the Sinclairs have made several claims regarding their ancestors, none of which are backed up by publicly available documents, and that therefore such extravagant claims should be taken with the required dosage of salt.

The evidence presented by Thompson contradicts claims by, amongst others, author Robert Lomas. According to Lomas, Rosslyn was built *"to house artefacts brought by the Knights Templar to Scotland in 1126. Between 1118 and 1128 the Templars excavated the ruins of Herod's Temple in Jerusalem. Hugues de Payens, first Grand Master of the Knights Templar, served on the First Crusade with Henri St. Clair, First Earl of Roslin and Hugues visited Roslin in 1126 where he was given land to build the first Templar Preceptory outside the Holy Land."* It is true that the first Templar Preceptory was built within spitting distance of the chapel, but there was no trace of a "Sinclair" on the scene. At that time, the land was owned by the "Roscelins". The land for the Preceptory was donated to the order by King David I, just as Roslin was given to the Roscelin family at about the same time by the same king.

Using this new research, some have looked towards Father Hay and have pointed to him as being responsible for inventing the descent from the Norwegian Rognvald. But the story is more complex. For one thing, their origins from France are not in doubt. It is only their arrival in Rosslyn that is dubious. But where there is one lie, there might be more, and hence their Norwegian origins have also been scrutinised. It was claimed that most of the Sinclair documents relating to the first two Earl Henrys of Orkney were lost at sea during a transfer of the archives to the newly-built Roslin library. This "loss" included documents attesting to the verification of the claims made upon the Orkney Islands by the Sinclairs. The islands were the object of fierce fighting between Norway and Scotland and the Sinclairs claimed these lands were theirs, on the grounds of their Norwegian ancestry. This is a claim they were unable to prove, as they claimed that this evidence also had been lost at sea during the transfer of the archives.

In the absence of the evidence, Bishop Tulloch wrote documents on the history of the Orkney islands, the *Genealogy or Deduction of the Earls of Orkney*, in 1446, which traced the claim of William, the Chapel builder and the third St. Clair Earl of Orkney, to Rognvald of Møre. This document was contrived to assume that the St. Clair's claim to the islands was legitimate. But this was debated - most likely because it was widely agreed that the claim was invented. It was not until later, under strong pressure from the Scottish crown, that King Erik formally granted

the earldom to William St. Clair. Interestingly, soon afterwards, it was that same Scottish crown that ordered the Sinclairs to surrender the Orkney Islands to the crown. It was a clever move on the part of the Scottish king first of all to remove the disputed land from a Scandinavian and possibly hostile presence so close to Scottish borders, then giving it to a leading Scottish family hired to co-operate in the trick, and finally bringing it under the king's own control.

Returning to the previous century, shortly after their marriage into the Scottish Roscelin family, the Sinclairs reached the forefront of Scottish politics. William St. Clair (William being a very popular name in the family) was one of five leading Scottish ecclesiastics to rally around Robert the Bruce and his cause: Scottish independence from England. His nephew, another William St. Clair, had been one of the Bruce's closest friends and retainers. On Bruce's death in 1329, it was this Sir William St. Clair, along with Sir James Douglas and four other knights, who would embark with Bruce's heart on a quest to the Holy Land. Setting off from Berwick by boat, they arrived without incident at Sluys in Flanders. However, crossing Continental Europe over land was less fortunate: in Teba, Spain, they were attacked by a group of Moors. Thrusting Bruce's heart into the enemy ranks, all but one were killed, though they did gain the respect of their opponents, who must have classed their actions as "foolish bravery". The heart of the Bruce therefore never reached the Holy Land. The sole surviving knight was allowed to return the bodies to Scotland. Robert the Bruce's heart was buried in Melrose Abbey; William St. Clair was buried in Rosslyn.

This William St. Clair also built a chapel, though not in Rosslyn, but in the nearby Pentland Hills. The Glencorse Reservoir in the Pentland Hills now covers the remains of the Chapel of St. Catherine in the Hopes. The chapel was built when William St. Clair made a bet with his friend Robert the Bruce, wagering his head against Glencorse Valley. If his hounds (called Help and Hope) killed a certain deer that had eluded all the huntsmen before it reached the Glencorse Burn, he would get the valley. The deer was brought down at the burn and St. Clair was declared the winner of the wager. He built the chapel as a thanksgiving.

4.3 Discovering America?

In the late 14th Century, Henry St. Clair achieved tremendous wealth. Henry was Earl of the Orkney Islands, Lord of Shetland, Admiral of the Seas as well as many other titles most would kill for but which, in his case, are hardly ever mentioned. His rank and influence were so great

that he was allowed to stamp and issue coins within his dominions, make laws and remit crimes. He has been described as second only to the king.

But along with his tremendous wealth some people have attributed a tremendous daredevil character to him. It is claimed that Henry St. Clair, together with the Venetian explorer Antonio Zeno, attempted to cross the Atlantic Ocean in 1398. They are believed to have reached Greenland and many speculate that they actually reached America, although no direct evidence for this claim exists. Two monuments, a fifteen-ton granite boulder and a replica Viking ship, have been erected in Novia Scotia, at Halfway Cove, Route 16 in Guysborough County, as a memorial. But did such a voyage ever occur?

The source of this "evidence" is the *Zeno Narrative*, a document published anonymously in 1558, almost a century after Columbus' voyage to the New World. It is actually believed it was compiled by Nicolo Zeno, in honour of his ancestors, the navigators Nicolo and Antonio Zeno. But as Brian Smith points out: *"Henry Sinclair and the Orkney Islands are simply not mentioned in the Zeno Narrative."*

Furthermore, the *Narrative* clearly states that "Zichmi", the hero of the account, landed in Greenland, not America. Supporters of the Sinclair-discovery of America claim Zichmi was a misspelling of "Sinclair". Even more, the document states that the journey of Nicolo Zeno occurred in 1380 - not 1398 - and that he was shipwrecked in Frislanda, an island larger than Ireland - hence not fitting the description of the Orkney Islands.

The *Narrative* states that it is there that Prince Zichmi rules as a "great lord" of Porlanda. After encountering trouble with the locals, Zeno is rescued by Zichmi and enters his service. Zichmi comes to hear of a voyage to the unknown lands of Estotilanda and Drogeo in the far west. Together with Zeno, Zichmi sets sail towards those lands, but they never reach them. Instead, they land on Greenland and explore its coastline.

According the Henry-supporters, Zichmi is not only Sinclair, but his lands were the Orkneys. But the *Zeno Narrative* and Map are quite detailed, and, to quote Shetland archivist Brian Smith again: *"If the Zeno map is the work of Venetian navigators who lived with the earl of Orkney for four and fourteen years respectively, they don't seem to have paid much attention to their surroundings."*

The linking of Zichmi to Sinclair occurred in the 1780s and was the work of travel writer John Reinhold Forster. To explain the missing Frislanda, he said it had been "swallowed up since by the sea in a great earthquake". Then, he suggested it had to be the tiny Orkney Island of

Faray - definitely much smaller, rather than larger, than Ireland. Forster's account was immediately attacked by Cardinal Zurla, but in the 1870s, Henry Sinclair's case was "rehabilitated" by Richard Henry Major, who stated the *Zeno Narrative* was erroneous: as a result, Major wrote what he felt Zeno "should have written", rather than what he actually wrote. Major was therefore rewriting a record of a document that had been labelled a mythical account, just to make it fit with the unsubstantiated claim that Henry St. Clair travelled to America. Faith might move mountains, but believers prefer the easier task of altering the evidence, it seems.

As a further result, the Sinclairs, in particular Roland Saint-Clair, an Orkney emigrant to New Zealand, was so delighted with this revised account that the entire Sinclair clan began to look towards the *Zeno Narrative*. In 1893, during the Chicago celebrations of Columbus' voyage, Thomas Sinclair lectured about Henry St. Clair, suggesting that he reached America before Columbus. That they and other people since have been misled, is largely due to the fact Major had rewritten history, and had made room for Henry St. Clair where no such accommodation had been before. With the rise in notoriety of Rosslyn Chapel, the allegation that Henry St. Clair reached America has become an established myth, believed by many, accepted with virtually no independent validation of the evidence, resulting in at least two monuments commemorating a voyage that never occurred.

Stephen Boardman has also shown that Henry St. Clair was at home throughout the period of his alleged voyage, fighting in the Borders in 1398 and subsequent years. Furthermore, evidence located in Italy shows that the Zeno brothers' movements for that period were accounted for; and they were not surfing the waves of the North Atlantic. In 1933, Andrea da Mosto showed that Nicolo Zeno was indeed a well-known navigator and public official from Venice, between 1360 and 1400. But in 1394, he was found guilty of embezzlement, this at a time when according to the Sinclair supporters, he was in the service of Sinclair in the Orkneys.

Furthermore, in 1898, geographer Fred Lucas showed that the *Zeno Narrative* was a concocted story and not a factual account of a voyage. The *Narrative* was a mixture of Columbus' letters, Vespucci's letters and various other works. The story was also based on that of Jeronimo Aguilar, who was shipwrecked off Jamaica in 1511. Finally, he showed that Estotilanda was drawn from 16th Century prints of Mexico, Cuba and South America, specifically Benedette Bordone's account of Mexico,

written in 1528, right down to the description of a mountain from which four rivers rise. Zeno borrowed most of the place names from Olaus Magnus's Carta Marina of 1539.

But perhaps the most overlooked evidence against Henry St. Clair can be found in the 17th Century, when Hay wrote major lies about the Sinclairs in order to enhance their reputation, but did not mention the story of Henry's voyage to America. That level of confabulation would only enter the scene a century later.

Nevertheless, further allegations that Sinclair reached America have been derived from a legend about "Glooscap" found among the Micmac Indians. Glooscap is said to have visited them and later sailed away home to a country in the east. It is said that he left a small colony behind. "Evidence" for this allegation is the so-called Westford Knight, known locally since 1880, and uncovered by Frederick Pohl in 1954. According to Pohl, a fervent promoter of the theory that Henry discovered America, the six-foot high carving resembled a knight in full armour. But detailed examinations by David K. Schafer, Curatorial Assistant for Archaeology at Harvard's Peabody Museum, reveals that the carving is in fact a T-shaped engraving surrounded by glacial scratches and weathering marks. Furthermore, Schafer discovered that around 1400, when the "knight" was supposedly carved, the area was within a forest and under three feet of soil, forcing the conclusion that the drawing is much more recent than the date proposed by the Sinclair supporters.

Finally, the so-called Newport Tower, on Rhode Island, Massachusetts, is indeed an enigmatic building, dating from anywhere between 1410 and 1971 AD. As such, it has been used by the Sinclairs to argue that Henry St. Clair sailed from Nova Scotia to Massachusetts, leaving the tower as "evidence" of this trip - even though the date of this voyage (1398-1400) is outside the period confirmed by carbon-dating. A new allegation, much better supported than the Sinclair link, has been made by Gavin Menzies, who states that the Newport Tower is described by Giovanni de Verrazzano, around 1524. The tower overlooks the harbour and, Menzies argues, was used as a lighthouse, guiding ships approaching Narragansett Bay. Menzies, like so many others, originally felt that the tower looked Romanesque and hence believed that it might have been built by Norsemen, who we now know were present along the Northern coastlines from the 11th Century onwards. So far, little difference between Menzies and the Sinclair supporters. But, argues Menzies, *"the Norse had little experience of lighthouse design and are not known to have built one overseas."* According to Menzies, the Newport Tower was

The shield of the Sinclairs is the engrailed cross. It can be found throughout the chapel, particularly crowning the ceilings of the aisles.

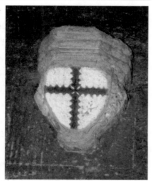

built by a Chinese expedition sent out by the Chinese Emperor in 1421, when the Empire was at the height of its wealth, in order to map the world. Menzies has pointed out that the tower closely resembles the lighthouse built during the Song Dynasty (960-1279) that guided the Chinese and Arab fleets into the port of Zaiton (Quanzhou), in southern China. Menzies believes that the Tower was built to guide successive ships into the harbour, although changes in the political climate in China meant that no ships ever entered the harbour, leaving the stranded sailors abandoned and intermarrying with the local Indian population.

In conclusion, there is no evidence to support the "Henry St. Clair discovered America" story. It is based on altered evidence and quite large leaps of faith. Nevertheless, the claim that Henry St. Clair reached America is not tied to any of the other myths surrounding the chapel: there are no supposed hidden treasures linked with this voyage, nor are there links to the origins of Scottish freemasonry.

The only "evidence" in the church is a stone depiction of what some claim to be maize, although that claim is subject to the eye of the beholder. Few have identified it as maize, with botanists saying it as a plant of unknown origin - hence most likely derived from the imagination of the carvers, who often had to "fill in" empty spaces in the chapel's decoration with plants. It is that same imagination, this time belonging to the Sinclair supporters, that has interpreted this imaginary plant as maize, in an effort to support Henry's voyage to America.

4.4 Mary Queen of Scots, the Sinclairs and treasure

The founder of the chapel was yet another Sir William St. Clair, the third and last Prince of Orkney. William St. Clair died on 3rd July 1480, before the chapel was completed. In 1471, King James III had ordered him to abandon his lands in Orkney. Upon his death, James III demanded that his territory should be broken up and divided amongst his sixteen children, to make sure that his descendants did not become all-powerful landowners, thus threatening the sovereignty of the king. From then on, the St. Clairs were to become "servants" to the throne,

rather than potential usurpers. Whenever Scottish independence and history rose to prominence, so did the Sinclairs. In the 16th Century, Scotland is best remembered for the intrigue and sad demise of Mary, Queen of Scots. It seems that the Queen Regent Mary of Guise relied heavily on the Sinclairs in her attempts to put her child, Mary Queen of Scots, on the throne of Scotland - if not England and France as well - and fighting off the Reformation that threatened the Catholic faith at the same time.

King James V's favourite commander of the Scottish troops was Oliver Sinclair - much to the displeasure of the other nobles. Religion was at the core of this envy. Father Hay accused the staunchly Catholic Oliver St. Clair and others of blinding James V to the Reformation.

But it was war, not religion, which would make Oliver Sinclair famous. In 1542, Oliver Sinclair commanded the Scottish Army that encountered the English troops near the river Esk at Solway Moss. Among the twelve hundred Scots captured by the English, he and several others were transported to London to be confronted by King Henry VIII. Oliver Sinclair swore allegiance to England, thus receiving parole. But in 1545, he broke his parole and was ordered to be imprisoned. Rather than serving time, he disappeared from history.

The brother of this commander was Henry St. Clair, the Bishop of Ross and, from 1541, Abbot of Kilwinning. In 1561, he was appointed to the Privy Council of Mary Queen of Scots. He spent a lot of time in France with the Guise and Lorraine family. While Mary was staying in France, she had taken one "Jehane St. Clare", i.e. Jeanne St. Clair, with her from Scotland, to act as a nurse. Most likely, this was a member of the Rosslyn St. Clair family.

His younger brother, John, was also a bishop and in 1565, he solemnised the marriage of Mary, Queen of Scots, to Henry Stewart, Lord Darnley, at Holyrood Palace. He was literally sealing the beginning of the end for Mary, for it was this marriage that would eventually result in her demise. It was also during this era that the Sinclairs seem to have become pivotal in Scottish politics - even exceeding the power of the reigning dynasty. A letter dated 21st March 1545 stated: *"The lords ordain William St. Clair of Roslin to produce within three days all jewels, vestments and ornaments of "the abbay and place of Halyrudhous (Holyrood)... put an ressavit within his place", so that the Cardinal and administrator may see them and that they may be "usit in this solmpnyet tyme now approchand, to the honour of god and halykirk and upoun the expens of the commendatar and administrator thai payand to the gentill men of the said place... the somme of xx lib. for thair labouris maid in keiping (tharof)."*

The letter shows that the Sinclairs had "privatised" certain public possessions of Holyrood Palace and its Abbey. The move was not appreciated by the government. In 1693, The Theatrum Scotiae mentions that *"a great treasure, we are told, amounting to some millions, lies buried in one of the vaults [of the Castle]. It is under the guardianship of a lady of the ancient house of St. Clair, who, not very faithful to her trust, has been long in a dormant state. Awakened, however, by the sound of a trumpet, which must be heard in one of the lower apartments, she is to make her appearance, and to point out the spot where the treasure lies."* This ghost story illustrates that the area and the Sinclairs were linked with a vast treasure - and according to this account, the privatised treasure was never returned to the rightful owners.

The National Library in Edinburgh contains a letter from Mary of Guise, the Queen Regent, writing in 1546 to Lord William of St. Clair of Roslin, in which she swears to be a true mistress to him and protect him and his servants for the rest of her life in gratitude for being shown "a great secret within Rosslyn".

This enigmatic clause in a royal letter to one of her loyal servants has obviously been the key to vast amounts of speculation as to the nature of the secret that the Sinclairs possessed that forced royalty into blind submission. It probably had something to do with the fear of the looming Reformation. The Sinclairs were a devout Catholic family and were aware of what had happened in England, where precious relics had been destroyed. The Sinclairs, givers of many royal treasures and "keepers" of the sacred relics, are believed to have secreted those relics away. Some claim that this treasure was more than just the normal treasures present in churches; it is claimed that part of it was the Holy Rood. It is true that the Holy Rood was lost in 1546, but not from Edinburgh's Holyrood Palace, but from the shrine of St. Cuthbert in Durham. The Holy Rood was amongst the booty - which also included the Stone of Scone - taken by Edward I from Scotland to England two centuries before. Nevertheless, the modern Scottish Knights Templar continue to believe that the Holy Rood resides in or beneath Rosslyn Chapel - a belief almost certain to be false.

But it is quite possible that the Sinclairs were entrusted with other Scottish treasures. When Oliver Sinclair was captured on 24th November 1542, his ultimate fate still unknown at that time, King James V was not only greatly worried about him, but also made an inventory of all his treasure, after which he apparently cried out: *"Oh fled Oliver! Is Oliver taken? Oh fled Oliver!"* A few days later, on 8th December, Mary, Queen of Scots, was born. James V died a few days later. Three years later, it

seems that the Sinclairs became the centre-piece in the quest for "missing jewellery". One can only wonder whether there is a connection between all these events. If so, a case can indeed be made that Rosslyn might still hold a treasure - though probably of a slightly more mundane nature than the mythical ones connected to the chapel. Then again, it might be much more valuable in monetary terms.

As mentioned, the Queen Regent Mary of Guise relied heavily on the Sinclairs. In 1556, she sent William St. Clair to France to ask for more support in her defence of Mary, Queen of Scots. During his year of absence, he was excused from his judicial duties and Mary of Guise swore to defend Rosslyn in his absence. Perhaps this is the real reason why, ten years before, she was shown exactly what she had to defend. In 1560, Mary signed, on behalf of Mary, Queen of Scots, and Francis an order allowing William St. Clair to attack rebels hiding in the Borders, the area to the South of Edinburgh that marked the border with England, and to apprehend them. William himself was given immunity from any criminal action he might have to take in pursuing this challenge.

Perhaps the best example of the Sinclairs' extremely close bond to Mary and the Catholic cause came when Mary, Queen of Scots, had been executed. The Lord of Roslin appeared at James VI's court in full armour rather than a suit of mourning clothes. When challenged, clashing his mail, he replied: *"This is the proper mourning for the Queen of Scotland."* It was clear that the Sinclairs felt that Mary's son had sold out - had sold Scotland to England, and Catholicism to the Protestants.

After the Reformation, it was a small miracle that the Sinclairs were able to hold on to their estates. Although officially they became Protestant, secretly they continued their Catholic allegiance. Andrew Sinclair believes that before the Reformation, the images of the Virgin Mary, the Apostles and Saints had already been removed from their niches and were hidden in the vaults, rather than being left present for destruction by Protestant mobs.

In 1615, yet another St. Clair named William was condemned to death for harbouring a Jesuit priest and holding a Catholic Mass at Rosslyn. In the end, only the priest was hanged, while the Lord of Rosslyn was reprieved by James VI, who was by then also James I of England and mindful of the family's long service to the dynasty (Mary of Guise being his grandmother). In his traditional method of dealing with matters sometimes too close to his own heart and family, James VI sent this Sinclair into exile in Ireland.

5. THE SINCLAIRS AND MASONRY

One of the most well-known claims that is linked to the family is that since the 15th Century, the Sinclairs have been the hereditary grand masters of Scottish freemasonry. If this was genuine, it would destroy the assumption of many - most of all, many freemasons - that the order does not predate 24th June 1717, when four London lodges convened to form the Grand Lodge of England. That date is accepted as the birthdate of Grand Lodge masonry. Over the past several years, substantial evidence has accumulated that freemasonry had been in existence for at least a century before 1717, but not in the organised format of the Grand Lodges. Does this organisation date back to the time of the building of Rosslyn Chapel, as some would have us believe?

5.1 The Scottish free mason

The claim is that *"in 1441 James II, King of Scotland, appointed William St Clair patron and protector of Scottish Masons; that the office was hereditary; that after his death, circa 1480, his descendants held annual meetings at Kilwinning."*
The claim of the hereditary grand mastership was included in Father Hay's documents. Thompson has stressed that Father Hay's own editor had problems when Hay couldn't prove his assertion of hereditary descent, to the point that the editor put a disclaimer in the Introduction of Hay's book: "It is said that James II about this time conferred the dignity of 'Grand Master of Scotland' upon Sir William St. Clair, in consideration for the elegant structures that he had built (e.g. the Castle and the Chapel). The editor of Father Hay's '*Genealogie*' is strongly of the opinion that this statement is very problematical, if not altogether "legendary". And he uses very potent arguments, and gives very good reasons, why he is unwilling to accept such a statement without further proof." Other masonic researchers, like Jasper Ridley, also conclude that the Sinclairs came to believe falsely they were the hereditary grand masters of the masons, merely because the stonemasons had always looked towards the family as their patron and as such, had invited them to their meetings. There was nothing peculiar about such patronage, as other nobles were often invited to other "lodge meetings", such as weavers, bakers, etc.

Two kinds of masons existed: the rough masons, working with the hard stone, and the "free stone masons", working with softer stone. The latter's name became shortened to "freemasons". As in many trades, there were masters and apprentices. The exception was Scotland, where

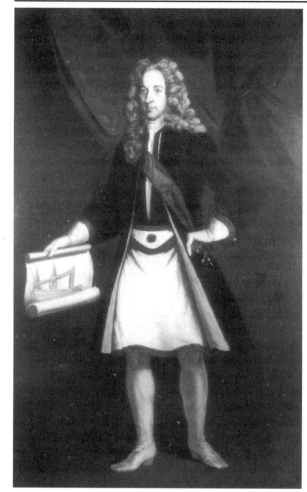

William St. Clair as first Grandmaster of the Scottish Grand Lodge of Freemasonry.

there was an intermediate degree: entered apprentice. Entered apprentices were allowed to perform most of the work of the master masons, but the latter did feel they needed to protect their own status and therefore introduced codes known only to other master masons. It is here, in "operative masonry", that the foundations for "speculative masonry", the "freemasonry" as we now generally know, were laid.

By the 18th Century, operative masonry had given way to speculative masonry. What is definitely known is that another William St. Clair was unanimously elected the first Grand Master of speculative masonic lodges by the thirty two Lodges at their meeting in Edinburgh on St. Andrew's Day, 30th November 1736.

After the formation of the English Grand Lodge in 1717, the Scottish Lodges decided to follow their example and created a Grand Lodge. The lodges stated flatly that William St. Clair was their hereditary grand master. This was somewhat strange, if only because Sir William St. Clair himself was not a freemason when they nominated him Grand Master. In order to be able to take up the function, he passed through all three degrees between May and December 1736. His first act was to renounce and resign in writing his hereditary rights of patronage, and institute

the system of election of officers of the new Grand Lodge. With this move, it seems that the Scottish masons tried to show their seniority over the English masons, even though in reality they were copying their example.

At the same time, this act showed the democratic nature that masonry wanted to convey. However, as all his male heirs had died at a young age, resigning his hereditary title, if he ever had one, was no major sacrifice to democracy.

Establishing seniority is a pre-occupation of many secret societies. This was particularly so in the 17th Century, when many masonic organisations claimed to be descended from the Knights Templar, and others went as far back as the ancient Egyptians, in an effort to show that the knowledge and rituals available to the members were worth those members' efforts. Bearing in mind the social rivalry between Scotland and England, it is clear that the Scots were trying to claim seniority over the English - and whenever the possibility arises of Scotland's fame coming to the forefront, the Sinclairs rise to prominence to help the cause.

William St. Clair was also pivotal in the establishment of a Golfer's House for the Honourable Company of Edinburgh Golfers. The golf club has existed since 1744, and it was transferred from Leith to its present location, Muirfield, between Gullane and Dirleton in East Lothian, in 1891. In 1768, St. Clair was referred to as the "undoubted representative of the Honourable and Heretable Grand Master Mason of Scotland", when he laid the foundation for the club-house. The ceremony was a masonic gathering. He was Captain of the club from 1761 till 1766 and again from 1770 till 1775. He was also president of the Archers Council, from 1768 until his death in 1778. The portrait of William St. Clair playing golf, painted by Sir George Chalmers, is one of the most famous of all golfing portraits, according to George Pottinger. The original hangs in Archers Hall, but a copy still hangs in the Smoking Room at Muirfield.

Even though he was still regarded as the Grand Master by his fellow golfers, William had been succeeded as Grand Master in 1737 by the Earl of Cromarty. That same year, with no heirs, he also sold many of his possessions, including the chapel and the castle. The chapel would eventually grow into a shrine for freemasons worldwide.

Robert Cooper, curator of the museum and library of Edinburgh's Freemasonic Hall, wonders whether it can be labelled as pure coincidence that at the death of William St. Clair, the first Grand Master, in 1778, the mason and printer James Murray decided to reprint a guide to Rosslyn Chapel and dedicate it "to the Ancient Fraternity of Free and Accepted masons". As Grand Master Archibald Orr Ewing puts it: *"It shows that*

Freemasons of the time were fascinated by Rosslyn Chapel."Indeed, it seems reasonable that this publication seems to have been the first major step in the promotion of the chapel's connection to freemasonry; the first step in the creation of the idea that Rosslyn chapel was a masonic temple.

5.2 "Hereditary grand masters"

So it is true that in 1736, Sir William St. Clair was called "hereditary grand master" by the freemasonic lodges. But at the same time, it is known this privilege does not date back to the 15th Century, as some sources, like Father Hay, would have us believe. When and under what circumstances, therefore, were the Sinclairs first considered to be the "hereditary grand masters" of masonry? For it seems that Ridley's conclusion that the Sinclairs were merely "mistaken" explains only half the story.

As mentioned, the idea that freemasonry only existed from 1717 onwards, has proved to be incorrect with the discovery of documents showing their existence in the early 17th Century. These documents also reveal that masonry seems to have existed from an earlier time in Scotland than in England. The historian David Stevenson has argued that in the 1590s, under the Scottish King James VI, the operative masonic lodges became organised and that the move from operative masons to speculative masons occurred in Scotland. In 1590, an Aberdeenshire laird was confirmed as having hereditary jurisdiction over masons in Aberdeenshire.

In 1598, William Schaw, the King's Master of Works, issued a code of statutes regulating the organisation and conduct of masons. How did this come about? Schaw was a Catholic and was suspected by the English agents of being a Jesuit. He travelled to France with Lord Alexander Seton in 1584 to bolster the old alliance against England. Together, they had befriended Queen Anne of Denmark, James VI's wife. This friendship was what had pushed Schaw to his exalted position; in 1583, King James VI appointed Schaw as Master of the Work and Warden General with the Commission of re-organising the Masonic craft. The masonic lodges of Edinburgh engineered the protection of the Sinclair family, stating they had been appointed hereditary grand masters, but that the office had passed out of use.

Two Sinclair Charters date from this period and are held in the Grand Lodge of Scotland's Library in the Freemasons' Hall in Edinburgh. The first one dates from 1601, when the masons petitioned William St. Clair (1580-1628) to become their patron and protector. The charter received

the approval of Schaw and urged that the Sinclairs were recognised as patrons, to settle the dispute. However, it needed ratification from the king, but he failed to do this. Schaw's death in 1602 and the king's move to London in 1603 might have been the most important contributing factors to that failure.

Some years later, in 1628, the masons petitioned his son, another William, with the second Sinclair Charter, making a similar appeal. Again, the Charter caused controversy at the royal court. When the check of the claims was made, opposition to the charter surfaced immediately. James Murray, the Master of Works, attempted to exercise

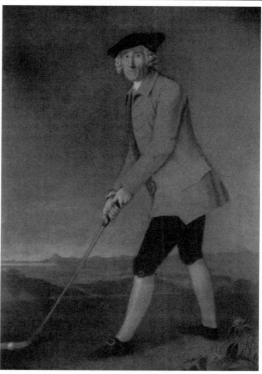

jurisdiction himself - and was successful in getting his claim legitimised. Truth was now secondary to intrigue and political power.

More interesting is what can be found in the second statute, which Schaw drew up in 1599. The importance of this document lies in the fact that it makes the first, veiled reference to the existence of esoteric knowledge within the craft of stone masonry. The so-called "art of

William St. Clair was the last direct descendent of the Sinclairs that built Rosslyn Chapel. He was also the first Grandmaster of the Scottish Grand Lodge of Freemasonry.

memory" was a mnemonic technique developed by the Greeks, but re-introduced into Renaissance Europe. Its presence in this document seems to suggest that the operative masons, and particularly the master masons, were familiar with this technique. In short, the "art of memory" created a mindset in which a chapel, for example, with its carvings, statues, etc. was used as a theatre to "tell a story". Features were placed specifically in certain locations in the chapel so that they could serve as "memory aids" during the telling of the story. However, it is unclear whether this "art of memory" was present inside the lodges, or whether Schaw tried to introduce it. For one thing, it is known that Schaw was very much a Renaissance Man and he was acquainted with several of the leading international figures of a radical movement that was taking Europe by storm.

When James VI became King of England, the drive to transform these lodges moved with him to England - where masonry would move from "operative" to "speculative". Stevenson has linked the move away from operative masonry to what is termed "speculative masonry" (i.e. freemasonry) - in essence, gatherings of people who are not masons, performing rituals related to the Temple of Solomon - to this transition period around the year 1600.

It is likely therefore that the "hereditary Grand Mastership" was invented around 1600, with the Sinclairs once again taking up the cause of Scottish independence in the face of the approaching unification with England. For, when the Schaw charters were drawn up, the masons stated that King James II had granted the hereditary title to Sir William St. Clair, the builder of Rosslyn Chapel, but that the documents had been destroyed by fire. By playing James VI against the undocumented claims regarding his forefather James II, the masons knew that the king would be most unlikely to risk upsetting the Scottish nobility again in those perilous times. Furthermore, choosing the Sinclairs and the builder of Rosslyn Chapel - a famous chapel even then - would not have seemed strange to James VI.

To all intents and purposes, if James II ever did consider granting this privilege to Sir William St. Clair, it was probably nothing more than he deserved. But historian David Stevenson believes that, in spite of the presence of evidence, the Sinclairs might have had a rightful claim as patrons of the craft, for *"if the masons had had a free choice in seeking a suitable patron to advance the craft's interests they would never have chosen the laird of Roslin"*, a closet Catholic.

Based on the fabricated links of the Grand Master of the Knights Templar

Hugues de Payens with a St. Clair and the misunderstood role of the Sinclairs in freemasonry, many authors have speculated that the Sinclairs are the vital connection between these two secretive organisations. For in the past few decades, if not centuries, various scholars and popular authors have been searching for a "missing link" that they believe connects the two orders together. As there is no direct evidence, it is clear that the Sinclairs play a prominent part in their theories. Therefore, it can be no surprise that the most visual remnant of the Sinclair family, Rosslyn Chapel, has been identified by many as the place where evidence for that link is supposedly located. Though it is most unlikely that the Sinclairs are this link, it has not prevented the strengthening of the mythical importance of Rosslyn Chapel in this transition.

6. FOUNDATION OF CHAPEL

Some have claimed that the chapel was not the first sanctuary on the site, but there is no evidence for this claim. Some claim it was a Roman temple of Mithras. Knight and Lomas believe that *"a megalithic chamber that involves a natural cavern well below the present building"* existed - and still exists. The Chapel, officially known as the Collegiate Chapel of St. Matthew, was founded by Sir William St. Clair. To make the distinction somewhat easier, his title of third and last Earl of Orkney is normally added to his name.

Between the William St. Clair who had died en route to Jerusalem with Bruce's heart and the builder of the chapel, the Sinclairs had attained tremendous wealth, particularly at the time of "Prince Henry". His son, another Henry, started to strengthen the bonds between the Sinclairs and the Douglasses, by marrying Egidia (or Gildes) Douglas, daughter of Sir William Douglas. When he died, around 1417 (some state 1st February 1420), the lands and titles passed into the hands of his son, Sir William, the builder of the Chapel. He is described as *"a very fair man of great stature, broad bodied, yellow haired, well proportioned, humble, courteous"*.

He married twice, first to Elizabeth or Margaret Douglas, daughter of Archibald, fourth Earl of Douglas. She *"was served by 75 gentlewomen, whereof 53 were daughters of noblemen, all clothed in velvet and silks, with their chains of gold and other ornaments, and was attended by 200 riding gentlemen in all her journeys"*, to quote Forbes. Hay described her as being next to the Queen in dignity.

On account of consanguinity and affinity, they were separated, in the old Church of St. Matthew, now in the cemetery below the chapel. However, a dispensation was obtained from the Pope and they were re-married in the same church. The couple had one son, William, and four daughters. When she died in 1452, he married Marjory, daughter of Alexander Sutherland of Dunbeath Castle, by whom he had five sons. This William St. Clair loved the name so much that he baptised no less than two of his sons William.

Who was this man? Father Hay claimed that Sir William St. Clair was a Knight of the Golden Fleece and a Knight of the Cockle. The Order of the Golden Fleece, founded in 1429 by Philip the Good, the Duke of Burgundy, quickly became the most prestigious order in Europe. The order's archives have remained intact, but they do not show that William St. Clair was a member.

As to the Order of the Cockle, no such order ever existed. Robert Brydon believes that as the clamshell in France is called "coquille St Jacques" and there was an Order di San Jago di Compostella, this is the order of which William was a member. However the order was exclusively for the ranks of the Spanish nobility, of which St. Clair was not a member. Furthermore, Alexander Nisbet in *A System of Heraldry*, published in 1816, states that Prince Henry St. Clair was a Knight of the Thistle, a Knight of the Cockle and a Knight of the Golden Fleece. Both the Thistle and the Golden Fleece claims are impossible, for at the period in which Henry lived, these Orders did not exist. It seems therefore safe to assume that Father Hay was mistaken in these assumptions, or had archives at his disposal where the role of Sir William was exaggerated.

Unfortunately, several authors have blindly quoted Hay's allegations. Even though Sir William lacked these international distinctions, the Sinclairs were famously rich in Scotland. So he decided to display the fortune of the family - in more than one way.

Less well known than the chapel, is the Rosslyn Hay manuscript. Gilbert Hay carried out a translation of a three-volume work that is now in Scotland's National Library. Dated 1456, it is the earliest extant work in Scottish Prose. Furthermore, as a work of craftsmanship, the heavily worked leather binding is recognised as one of the most important examples of its kind in the British Isles. The manuscript was originally part of the library of the castle, which was looted in the 17th Century. It is a translation of René d'Anjou's writings on chivalry and government.

René d'Anjou was a French King and it is possible - though unsupported - that William St. Clair met him. It is known that Sir William and his wife spent a lot of time in France. Furthermore, it seems that William had decided to maintain a library and scriptorium. Some of the works produced at Rosslyn are known to have originated at Anjou and by investing in both the translation and the reproduction of important manuscripts, Rosslyn performed the same function that the Anjou family played in France.

Furthermore, Gilbert Hay was one of Europe's most educated men and William's tutor. As John Ritchie has pointed out, Hay was also famous for his translation of the popular legend of *Alexander the Great and the Earthly Paradise*. In this tale, very similar to the Grail legends, a stone is sent to the leader from the gates of the earthly paradise. The stone restores youth to the old and is described as brilliant, rare in hue and like a human eye, weighing more than any quantity of gold yet, if covered with dust, could not outweigh a feather. It is said that when Alexander learned about this, he abandoned his ideas of world conquest.

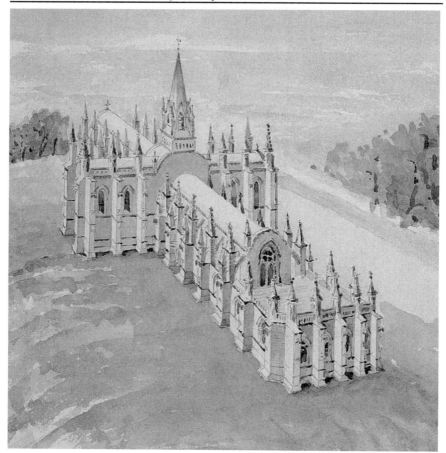

Artist's interpretation of original design of Rosslyn Chapel, of which only a part eventually became built.

True importance and stature, however, seem to have been measured by building churches, rather than housing books in private libraries. More than thirty-seven collegiate churches were built in Scotland between the reigns of James I (1406) and James IV (1513). They were secular foundations intended to spread intellectual and spiritual knowledge, and the extravagance of their construction depended upon the wealth of their founder, which, in the case of the Sinclairs, was more than substantial. Rosslyn Chapel and Seton Collegiate Church, built by the Seton family, who were close friends of the Sinclairs, are now amongst

the most famous in the Edinburgh area. Both are listed buildings and part of Historic Scotland. Father Hay states that the foundation stone was laid in 1446, but according to another chronicler, Captain John Slezer, the building began six years earlier, i.e. in 1440. Walter Bower, in the *Scotichronicon*, dated to 1447, says that, *"Lord William St. Clair is erecting an elegant structure at Rosslyn."* However, the date carved in the masonry is 1450 and as this is the only direct source, it would be prudent to use that date, even though 1446 is the more popular one.

Furthermore, Judy Fisken, former curator of the Chapel, notes that Rosslyn Chapel was dedicated on 21st September 1450 as The Collegiate Church of St. Matthew. September 21st was not only the Autumn Equinox, but was also the feast day of St. Matthew. The Chapel was re-consecrated during its actual building. A Papal Bull was issued to that effect. At the time, there was already a St. Matthew's Church some hundred yards down the southern slope of the hill, in what is now the cemetery. People have therefore wondered what moved him to build Rosslyn Chapel. According to Hay, *"his age creeping upon him, made him was to come. Therefore... it came into his mind to build a house for God's service, of most curious work, the which, that it might be done with greater glory and splendour, he called artificers to be brought from other regions and foreign kingdoms..."*
However, the building of chapels was, as mentioned, a vogue that hit Scotland - could one of the wealthiest men in the country afford to be left behind? William also built a church of St Duthacs outside Kirkwall, on Orkney. It seems more likely that William had to "keep up with the Jones's", which in his case included the Forresters in Corstorphine (now a suburb of Edinburgh) and the Setons, in what is now Port Seton, all friends and allies of the Sinclairs, all of them engaging in the building of Collegiate churches. William would surpass all of them, which was most likely what he set out to do, for in wealth and esteem, he surpassed them all.
It is reported that masons were brought in from all over Europe (France, Italy, Spain and Portugal) as well as Scotland and that they were housed in the village of Roslin. Master masons were paid a staggering forty pounds per year, while the lesser masons were paid the handsome sum of ten pounds per year. Though tremendous wages, it was, in truth, not staggering for "free masons". Labour shortage was acute, particularly for the skilled work that freemasons were asked to perform. In the case of Rosslyn Chapel, as can be judged from the final result, the skills had to be equal to their pay. Furthermore, because of the shortage of labour, the bargaining power of the master masons was vast and their employers knew that money alone would bring them in, possibly make them stay,

for many of them often left mid-work to take up better paid employment elsewhere.

The influx of foreign masons for Rosslyn Chapel's building was therefore due to the shortage of labour in Scotland and England (many of them were employed in the building of the other Collegiate Churches), made worse by the knowledge that William St. Clair no doubt wanted the best, to surpass all the other churches.

The building, made wholly out of stone, took forty years to build -not an unusually long period in those days. A stone seat was allegedly built along the outside end of the building to allow the prince to enjoy the view of his castle in the distance, as well as progress on his chapel. The building work was laborious because first of all, everything was drawn on wooden boards, then it was carved into a model by carpenters and finally it was executed by the stonemasons. The amount of effort seems excessive, but perhaps it is evidence of a language barrier that existed between the founder and the masons, or maybe of the extensive involvement William himself exercised over the project. Assuming the masons were foreigners, William might possibly have used this convoluted method to guarantee the carvings were accurate, employing draughtsmen and carpenters who were able to understand his wishes, instructing them to create the woodcuts, which could then be copied by the foreign masons. But it is known that the transference from paper to wood to stone was not done with one hundred percent accuracy: when the masons were unsure of the master's intentions regarding certain aspects of a carving, they are believed to have decorated it with foliage, rather than leave it blank. In 1476, no doubt feeling old age creeping up on him, he drew up a charter (in essence his will), making sure Rosslyn and most of his possessions would not go to the eldest son of his first marriage, but to Oliver, the eldest son of his second marriage. The nickname "the Waster" seems to betray why his father felt the possessions would not be safe with his eldest son. In 1481, however, the two brothers would renegotiate the titles, no doubt because the elder brother had already started to deplete the resources of the Barony of

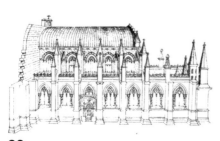
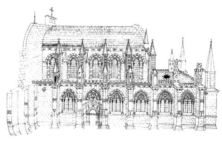

Newburgh in Aberdeenshire, which he had held since 1450.

After Sir William died in 1484 (for some reason, some authors have him succumb on 3rd July 1480), he was buried in the unfinished chapel. The rest of the building work was overseen by Oliver Sinclair, but it seems that he merely completed what would eventually become the choir of what was intended to be a larger cruciform building with a tower at its centre. Apparently, the foundations of the nave were excavated in the 19th Century and found to extend ninety-one feet beyond the chapel's original west door, under the existing baptistery and churchyard. Radar analysis by Ground scan carried out in the 1980s has revealed the foundations of a large cruciform church beneath the present churchyard. But in what is now called Rosslyn Chapel, there is still evidence on the pillars, walls and in the carvings that this building was in essence unfinished and certain features were finished quickly so that the project could be signed off. To quote former curator Judith Fisken: *"At the death of the founder the Chapel was made wind and water tight, no further work was done."* In 1890, it was estimated that the building would have cost 400,000 pounds.

7. THE HISTORY OF THE CHAPEL

Rosslyn Chapel was a Catholic chapel. The founder had endowed it with provision for a provost, six prebendaries and two choristers. In 1523, his grandson, William, endowed it with land for dwelling houses and gardens.

When the chapel was barely fifty years old, the Scottish Catholics were hit by a rebellion, now termed the Reformation. On 26th February 1571, just forty-eight years after the endowment, there is a record of the provost and prebendaries resigning because endowments were taken by "force and violence" into secular hands as the effects of the Reformation took hold. As the Sinclairs were staunch Catholics, it was clear that they - and therefore the chapel - were in for a rough time. In 1589, William Knox, brother of John Knox and minister of Cockpen, was censured "for baptising the Laird of Rosling's bairne" in Rosslyn Chapel, which was described as a "house and monument of idolatry, and not a place appointed for teaching the word and administration of the sacraments".

It seems that the contemporary owner was one Oliver St. Clair, even though the Hay genealogy mentions a William St. Clair being the owner. He was not allowed to bury his wife in the chapel and afterwards, he was warned repeatedly to destroy the altars. In 1592, he was summoned to appear before the General Assembly and threatened with excommunication if the altars remained standing after 17th August 1592. On August 31st, it was reported that the altars had been demolished. However, the Sinclairs still maintained their allegiance to the Catholic Church, even though outwardly, they had become Protestants. Although it seems that the Sinclairs continued to use the chapel secretly for Catholic services, the building itself began to decay. The deceased Sinclairs, however, were still being buried in the vault.

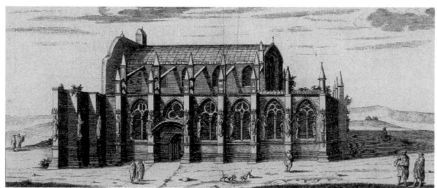

During the Battle of Dunbar in 1650, Cromwell's troops besieged the countryside and stabled their horses in the chapel. Cromwell himself apparently ordered his General Monck to "leave the Chapel alone". What was the reason for this special treatment? It is claimed that Cromwell, as a Master Mason, was aware of the Chapel's significance to the Masonic movement. Monck therefore proceeded to batter Rosslyn Castle to ruins, but the Chapel (apart from a few musket shot holes) remained intact.

On 11th December 1688, after William of Orange had displaced the Catholic James II of England, a Protestant Edinburgh mob and local villagers pillaged Rosslyn Castle and entered the Chapel. They destroyed many of the images in the enriched niches, but moral lessons, such as the Seven Virtues, the Seven Deadly Sins and the Dance of Death, survived. The attack illustrates that even after decades of neglect, no-one had forgotten that the true allegiance of the chapel was to the Catholic cause - and the chapel had to bear the full force of dissent to that cause.

Many people have asked whether it can be a coincidence that the chapel was repaired in 1736, the same year that William St. Clair was made Grandmaster of the Freemasons. The windows were glazed for the first time, the roof was repaired and the floor was relaid with flagstones. Though intriguing, the "coincidence" is just not there: it was not William, but the new owner who had these restorations carried out, in 1739. William St. Clair had sold the castle and the chapel to General St. Clair. The reason for this was that by 1736, William knew that he would not have an heir. His only surviving daughter was Sarah, who was married to Sir Peter Wedderburn. After selling the estate in 1736, William St. Clair lived in a small house at the bottom of Liberton Wynd in Edinburgh, overlooking Cowgate.

It was during 1762 and the late 1790s, with the direct family interests abandoned and Alexander being Lord High Chancellor of England, holding lands in Surrey, that the chapel suffered the most from neglect. When Dorothy Wordsworth visited it on 17th September 1807, she remarked: *"Went to view the inside of the Chapel of Roslyn, which is kept locked up, and so preserved from the injuries it might otherwise receive from idle boys, but as nothing is done to keep it together, it must, in the end, fall. The architecture within is exquisitely beautiful."* Despite this neglect, the chapel received many visitors, including Queen Victoria, who often stayed in Edinburgh with her husband, Prince Albert. During her visit on 14th September 1842, she expressed her opinion that it should be re-opened for worship, which inspired the owner, James Alexander St. Clair Erskine, to restore the chapel. He had stained

glass put in the windows and added an altar to the sacristy. The carvings in the Lady Chapel were also attended to.

The chapel was rededicated on Easter Tuesday, 22nd April 1862, by the Bishop of Edinburgh and the Bishop of Brechin. Sunday services could now be held, even though these were Protestant - not Catholic, as the builder had intended.

The connection with freemasonry was also rekindled around this time. Francis Robert St. Clair Erskine, James' son, was elected 69th Grand Master Mason of Scotland, on 14th January 1871. He was also the Head of the Supreme Grand Royal Arch Chapter of Scotland. He had been initiated in 1851, in the Lodge Kirkcaldy, and since 1855, he had been Substitute Grand Master. In 1870, the year before his election as Grand Master, he hosted a "Grand Masonic Fette" in Roslin. Over six hundred freemasons with their wives, daughters and sweethearts (in total more than a thousand people) attended what was labelled by the press as "this brilliant affair". The following year, Lord Rosslyn stated he should not be nominated for re-election. But a petition went around all lodges, collecting almost seven thousand signatures, requesting his Lordship to reconsider - pressure to which he gave in. The huge white scroll showing all the signatures, now on a wooden wheel, is still on display in Rosslyn Castle.

Shortly afterwards, in 1880, he decided to add a baptistery with an organ loft onto the western wall of the chapel - the only building work that changed the chapel's original layout. Again, ignoring the desire of the builder, he used wood for the oak tracery inside the baptistery. Its future was looking bright. In 1915, an inspection showed that it was in "fairly good order and requires very little done to it... a few of the stones are crumbling but not to the extent to cause any alarm. The condition of the roof is not satisfactory...and there are a number of gaps and cracks all over." It was recommended that the roof was covered with asphalt and this was carried out.

In 1930, Dr. Karl Hans Fuchs, a German Nazi with esoteric interests, is alleged to have inspected the chapel, accompanied by somebody who signed the visitors' book as D. Hamilton, possibly the Duke of Hamilton. Later, at the Theosophical Society in Edinburgh, Fuchs declared that Rudolph Hess, soon to be second only to Adolf Hitler, claimed to have Hamilton blood in his veins. Rudolph Hess, according to Fuchs, believed that Rosslyn was the Grail chapel "where the black hand snuffed out the candle". The origin of this belief was the research of one Walter Johannes Stein, an Austrian Jew who had fled to the United Kingdom in 1933, where he developed an interest in Rosslyn Chapel. He also become Churchill's adviser on the occult and secret intermediary with

King Leopold III of Belgium. Stein believed the Templars had taken the Grail from a spiral pillar near Cintra in Portugal to its sister chapel in Rosslyn. Stein was approached by Rudolph Hess, who, like so many other Nazi leaders, had a strong interest in the Grail and other esoteric material - especially of its potential to influence the masses. It is often speculated that Rudolph Hess' flight to Scotland in 1941 was connected to this, though it seems that that mission had singularly political ambitions. However, the possibility that Hess was tricked into coming to Great Britain has never been dismissed by some authors. One wonders therefore whether Rosslyn might have been given as a "teaser" to come over on such a dangerous mission - a mission that would alter the course of the Second World War.

But this interest of the highest Nazi circles seems to have left the local villagers cold. In 1942, the chapel was almost closed for a second time when a government official wrote to the Minister of Labour, Ernest Bevin, that *"... the Episcopalian Church at Roslin was almost empty every Sunday... on a recent Sunday there was a congregation of only two, and apart from the Clergyman's labour there must be other workers employed in cleaning and looking after the church and I suggest that steps are taken to close it down."* But the Minister of Fuel felt that he could not "imperil the eternal salvation of one Scottish Episcopalian" and therefore the chapel remained open.

Ever since then, the chapel has become the focus of extensive restoration works. Green algae were removed in the 1950s, but the most visible process happened in March 1997, when a free-standing steel structure was erected to cover it. This will enable the stone fabric of the roof vaults to dry outwards, away from the carved interior surfaces. The structure will remain in place until 2005.
Rosslyn Chapel is currently owned by the family trust of the Earl of Rosslyn, who now works as a senior officer in the Thames Valley Police. Now administered jointly between the Friends of Rosslyn Trust and Historic Scotland, with grants from many institutions and organisations, everything is being done to restore the church to its original glory and to make it a major visitor attraction. Today, weekly services are held inside the chapel, which can also be booked for weddings, and it is a venue for musical evenings. The chapel is the only medieval building to be used regularly by the Scottish Episcopal Church.

From the mid 1990s onwards, a steady stream of books has been produced in which various theories have been put forward as to what may or may not be hidden in or under Rosslyn Chapel (see the appendix

for an overview). This resulted in continued attempts to gain approval for various explorations of the chapel. Of course, proposals to "smash open the Apprentice Pillar" are never granted, but modern technology has brought about a new arsenal of non-destructive, often remote survey methods that can identify the presence of caverns, presence of metals, etc.

The first potentially successful proposal came from two authors, Robert Lomas and Christopher Knight, whose first book, *The Hiram Key*, was launched inside the chapel in 1996. As a consequence, a proposal for non-destructive scans was created, which received the support of Historic Scotland. The Rosslyn Chapel Trust, however, first approved, then withdrew the permission. To quote Knight and Lomas: *"They suggested that we might be able to work with them on future, commercially based scanning, but we would be required to agree to keep the results secret and even deny that the scans had happened if so required by the Trust."* They declined, but a befriended scholar, James Charlesworth of Princeton University, filed one their behalf. The Trust has not acknowledged this proposal. Rumour goes that the Trust have used the services of an Edinburgh firm to do non-destructive scans, and that the results of this scan have been kept a secret.

In 1997, Niven Sinclair and a few friends did what could be described as "ad hoc" exploratory excavations in the vicinity of the Chapel. Soon, they discovered the existence of a tunnel that lead from the chapel to the castle. Equally soon, Historic Scotland became aware of this work going on and stopped the exploration, which involved a camera on a 32-foot pole. Niven Sinclair described the tunnel as "huge and very deep underground" at the point where it enters under the foundations of Rosslyn Castle.

Beneath the floor of the crypt is a flight of steep steps, leading in the direction of the main building, to a vault directly underneath the engrailed cross in the chapel roof. A tunnel connects this vault with the castle; its location is directly below the south door, at which it is three feet wide and five feet high. Its roof is eight and a half feet below ground level. After a straight run of approximately twenty five feet, the passage turns ninety degrees towards the east and then drops down the hillside, its roof twelve and a half feet below ground level. The tunnel then continues under Gardener's Brae towards the castle. Anyone can try and trace the tunnel in the landscape; what comes immediately to mind is that the tunnel would extremely steep in places.

Robert Lomas and Christopher Knight have highlighted that the design mimics the design of a similar tunnel connecting the Palace of Solomon

with the Temple of Solomon, as mentioned in the mythology of freemasonry.

All remained relatively calm until 2003. Then, the newspaper *Scotland on Sunday* (the Sunday edition of *The Scotsman*) complained about the "absent landlord" Peter Lougborough, the Earl of Rosslyn. Loughborough had been at the heart of a national controversy: in charge of police protection of the royal family, Loughborough's credibility was officially challenged when a stand-up comedian evaded the security measures during Prince William's 21st birthday party at Windsor Palace, gaining access and possible control of the royal family. Bringing the national news story down to the local drizzle, the article reported that Loughborough had received large amounts of funding for the preservation of Rosslyn Castle, a house next to the Chapel (College Hill House) and the Chapel itself; yet the public had received no benefits from this public money; in fact, certain people had complained that access to the Castle had been refused, even though under the terms of the agreement, this should not be possible. In fact, Loughborough seemed to receive financial benefits from all, including, it seems, money paid from the Trust to the Earl for the monstrous construction hovering over the chapel.

Apart from the owner, the Trust also became the centre of controversy. I myself experienced this first-hand: preparation for the first edition of this book was underway in 2001. It is local knowledge - underlined in the newspaper article - that the chapel and everything connected with it is seen as a money-making, if not myth-making machine by those operating it. When I approached the Project Director of the Trust about the creation of the book, and later of the existence of the book, I twice received extremely negative, but insightful comments. On the first occasion, he phoned, stating the book was seen as direct competition with their own guide, and as such would not be sold on the premises - despite the fact that this book is one of handful of books - and the first by a non-Sinclair or Sinclair-sponsored - solely dedicated to the chapel. This book also goes against various unfounded allegations made in other books on sale in the bookshop, books which promote the fame of the chapel, but not the "understanding" of the chapel. On the second occasion, the Director had either forgotten the first correspondence, or chose to neglect it, and informed me of his outrage that such a book had come about without his approval!

At the same time, John Ritchie, a native of Roslin, had created an international stir by stating that a ground scan of Rosslyn Chapel would soon take place. This scan would occur from Gardener's Brae and as

such would be able to scan for anything underneath the chapel, by directing its beam horizontally. This greatly upset the Project Director again, but there was nothing that he could do about the situation, as the area is not in the ownership of the Trust. The Trust, and particularly the Director, then embarked on a rather desperate campaign, which resulted in public mud slinging against Ritchie and various others, whereby - as always - far too willing and far too simple minds (as usual operating on the Internet) sided with the loudest, rather than the wisest. One important stake was, of course, the known existence by Ritchie, as well as the Trust, of the subterranean tunnel, a major discovery which they knew would become public knowledge once the scans occurred. The fact that Ritchie had the eyes and ears of the international media meant the Trust could do nothing but wait, and blasphemy "the opposition". The Trust was furious as this tremendous revelation would occur without their control - and reading from the evidence, one could argue the Trust actually tried to suppress awareness of the existence of this tunnel.

In 2001-3, somewhat enigmatic modifications were made to one part of the crypt: they could be interpreted as a one-time attempt to foil plans relating to the tunnel - but plans, it seems, never carried out, hence resulting in a useless building. Knight and Lomas describe parts of this work as follows: *"the wide trenches dug across Gardener's Brae, to lay fairly modest drain pipes."*

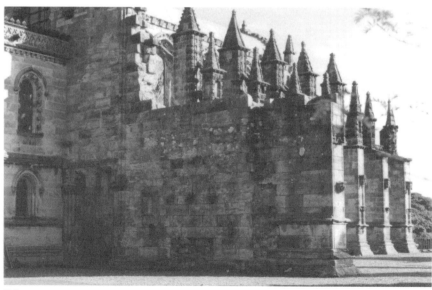

Though it is doubtful the tunnel will reveal great secrets, the tunnel itself is a major discovery and as such, Lomas and Knight decided to incorporate it in their book, *The Book of Hiram*, published in 2003. This meant that the existence of the tunnel stopped being a local story, and entered the public arena.

8. GUIDE TO THE CHAPEL

One guidebook to Scotland describes Rosslyn Chapel in the following way: *"It is in some respects the most remarkable piece of architecture in Scotland... when looked at from a strictly architectural point of view, the design may be considered faulty in many respects, much of the detail being extremely rude and debased, while as to construction, many of the principles wrought out during the development of Gothic architecture are ignored. But, notwithstanding these faults, the profusion of design, so abundantly shown everywhere, and the exuberant fancy of the architect strike the visitor who sees Rosslyn for the first time with an astonishment which no familiarity ever effaces."*

This is what makes Rosslyn unique: it is quite small, yet looks big, almost like a Gothic cathedral. Its atmosphere is quite unique also. The interior gives the impression of walking around in a garden, a forest. There is an exuberance of trees, leaves, plants, etc. It is a garden, made out of stone. Interspersed amongst the vegetation, particularly around the windows, are depictions of angels.

Throughout the building, there is an abundance of small carvings that attract people's gazes, causing them to wonder what it might all mean. Every little ornament has been subjected to a painstaking analysis, often by people who feel that the smallest detail is a clear, but not yet understood clue, in unravelling the secret of the chapel.

8.1 Interior

Although it is a consecrated chapel, the majority of the features giving it the typical chapel "look" are Victorian additions, including the baptistery with the font, as well as a statue of the Virgin Mary with Child and the stained glass windows.

Rosslyn chapel is remarkably well preserved, considering its history as a horse stable at one point. Furthermore, Robert Brydon, the archivist of the modern Scottish Templars, is convinced that most of the damage in the chapel is *"very specific, not done by accident... Someone has deliberately damaged parts of it for a reason"*. However, it is known that angry mobs had a go at the interior on many occasions.

The entire chapel is made out of stone. No wood was used, apart from the 19th Century additions. Many art historians have stated that the architecture draws on the riches of almost every phase of Gothic architecture except that which was present in England at the time. Knowing that many of the artists came from abroad, this is hardly surprising. One writer, Ferguson, believes that *"there can be no doubt*

that the architects came from the north of Spain". He felt some features were characteristic of the churches of Burgos and Oviedo, as well as old churches in the South of France.

If there was stained glass in the windows, it did not survive the Reformation. For one hundred and fifty years, the only protection from the elements were shutters on the outside of the windows. Their iron hinge pins are still visible. The shutters were removed when the windows were glazed with clear glass in 1736. Another one hundred and fifty years later, the stained glass windows were added, though some of the stained glass, in the baptistery and in the crypt, is more recent.

The themes that recur most frequently inside the chapel are angels and an engrailed cross. The engrailed cross is the Sinclair Coat of Arms. It is said to represent the appearance of a shining cross in the sky. It is a common depiction in this chapel. On the north side, there is an angel holding the engrailed cross. The ceilings of the gallery carry it, as well as the ceiling of the crypt, the stone framework holding the main stained glass windows of the baptistery and the upper East Wall.

Thompson wrote: *"It appears to me that there was a general purpose and design for the whole building, but the details of the work, and especially the carvings, were left to be developed as the work proceeded; and so each individual workman was permitted, if not encouraged, to try his skill."* This might explain the diversity, or richness, of decoration.

Author Keith Laidler compares the illustrations of Rosslyn Chapel with the tactics of a herd under attack: there are so many possible preys, that the animal does not go for a single beast, but becomes confused, and spoilt for choice, makes half-hearted attempts at several beasts, never catching a single animal. *"I felt a grudging respect for the old Templar: Sir William had filled his 'chapel' with so many figures that one became confused, hopping this way and that but never being able to settle for long on one object or to decide which was most important."* Over fifty percent of the carved figures, particularly the angels, are carrying either scrolls or books. The angels can be found most often next to the bottom corners of the windows, as well as in the Lady Chapel, where they can be seen playing various musical instruments, including a bagpipe - making the history of this instrument far older than some would like to accept. There are more than one hundred depictions of the so-called "Green Man", a Celtic symbol. Along the walls, ceilings, arches, etc. are streams of foliage, leaves from various flora, giving the impression that one is inside a stone garden. Amongst the foliage are hart's tongue

ferns, curly kail, trefoil, oak leaves, etc. The rose and the sunflower are the most often repeated flowers in the building.

The binding of the Rosslyn Hay manuscript shows the Agnus Dei, the Lamb of God. The depiction is also present in the chapel. Andrew Sinclair points out that *"other mysterious symbols were stamped on the binding of the ancient manuscript as well as being repeated in Rosslyn Chapel... Most oddly, there was a unique stamp of a lion standing on its hind legs and fighting a dragon - reproduced exactly on the top of a pillar in the chapel. Evidently, William St. Clair used his extensive library to institute the manufacture of more books at Rosslyn as well as to find designs for the carvings in his new chapel."*

Books in the Middle Ages were called flower gardens or rosaria, arbours of roses. They were often illuminated with flowers, as is the case in Rosslyn chapel, a stone book. The flowers represented the search for wisdom and faith. It seems, therefore, that even the extreme amounts of foliage and roses inside the present chapel were inspired by his library.

Entrances

Originally, the chapel had two entrances: one in the North Wall, which is now the main entrance, and one opposite, in the South Wall, which is now normally closed. With the addition of the baptistery, a western entrance was added, going through it.

It is believed that the two original entrances were put in to allow easier separation of the sexes. The North door has, for at least a century, been called the "Bachelor's Door".

Another entrance was available from the crypt (sacristy), which enters the chapel via the steps at the Eastern wall.

North wall

Lining the North and South wall, is a continuous stone bench. In the days when the congregation stood during mass, the elderly and weak had seating provided along the walls on these stone benches.

William St Clair gravestone

To the right of the entrance, is the tombstone of William St. Clair. His name is written in Lombard lettering: Willhm de Sinncler. This is believed to be the gravestone of the William St. Clair who fought with Robert the Bruce at Bannockburn and was killed in 1330, en route to the Holy Land to fulfil the last request of Robert the Bruce. This was to travel to the Holy Land on a crusade, something he had never been allowed to do in life because of a medical condition (and his excommunication).

En route with three other knights, including Sir James Douglas, they were surrounded by a Moorish cavalry in Spain. They flung the casket containing Robert the Bruce's heart into the enemy ranks, charged the army and were slaughtered. The sole survivor, Sir William Keith, was given the relic and the bodies, to be returned to Scotland.

The bones of William St. Clair were buried in Rosslyn. The gravestone does not mark a place of burial as in 1873, the tombstone was moved from the castle to the chapel, although others believe it was moved from the site of an older chapel, in what is now the village graveyard. The size of the stone suggests that it was intended as a tomb marker rather than an exterior grave slab, for which it would have been rather small.

Below, a modern slab says "Knights Templar", but this is definitely not the case. None of the Sinclairs were Knights Templar. The central motif on the stone is a sword and a floriated cross, forming a chalice or a grail. Author Andrew Sinclair has described this gravestone as a "grail stone". *"A chalice was carved along the granite slab, which was only three feet in length. Within the cup at the top was an eight-pointed cypher of the Templars, which referred to the Holy Light within Christ's blood in the shape of an 'engrailed' octagon with a rose at its centre. [...] The base of the Grail or chalice formed the pattern of the steps of the Temple of Solomon."*

The gravestone of William St. Clair, who accompanied the heart of the Bruce on its crusade to Jerusalem.

Caithness memorial
The impressive memorial against the west wall, next to the William St. Clair gravestone, is in memory of George, the grandson of the builder and the last Sinclair in the possession of all the St. Clair lands of Caithness, Sutherland, Fife and Rosslyn. He agreed, like William before him, to subdivide his possessions amongst his three sons. Both were always at the request of the king, to reduce the power of the family, which would otherwise have been the wealthiest in Scotland.

Originally, the tomb was on the West side of the third pillar, but it was removed by General Sinclair to its present location, because in its original location, it spoiled the appearance of the Chapel.

Lovers turning away from the Devil towards God
In the window next to the entrance (on the right as one enters) is a depiction of two lovers next to the Devil. They are turning away from him and are said to be looking towards the angel holding a cross, on the other side of the window. It is a typically medieval rendering of

how "acts of the flesh" are believed to lead to the Devil, but resistance is possible by looking towards the cross of Christ. Note the typical depiction of the Devil: horns and big ears.

Agnus Dei
At the top of the pillar between the third and fourth window 45 from the right, on the east side, there is a carving of the Agnus Dei, the Lamb of God. This depiction, like that of two knights on one horse, was used by the Knights Templar as a seal. There are authors who have used this carving to make a link with the Knights Templar and their knowledge, which is believed by

The lovers turn away from the devil, towards the angel holding a cross on the opposite side of the window.

some of them to be incorporated into the design of the chapel. However, depictions of the Lamb of God were quite common. In the middle of the 15th Century, they were frequently used as a reminder of the fate of the Knights Templar. As Rosslyn was close to the Templar Preceptory, this should cause little surprise.

Lady Chapel (Retro-Choir)

The Lady Chapel, or Retro-Choir, is by far the most ornamented part of the chapel. It seems clear that the carvers started at the eastern part and worked their way to the western part, which, in the end, was abandoned. In my view, the carvings of the Lady Chapel are the most intricate of any church or chapel and this makes it worth the visit, purely for its architectural value.

The Lady Chapel is delineated by the eastern wall of the chapel and by three pillars in the west, the so-called Master, Journeyman and Apprentice Pillars. It is 7ft. 6ins. wide and 15ft. high. The floor is raised one step above that of the Choir. The railing that separates the Lady Chapel from the rest of building was an addition made at the end of the 19th Century. Originally, as can be seen in old paintings of the chapel, this was open, as it is, for example, in the "Lady Chapel" at Glasgow Cathedral. Radar analysis using Groundscan, carried out by author Andrew Sinclair, revealed the presence of a metallic shrine underneath the floor (see elsewhere).

Eastern wall (inside Lady Chapel)

Altars
Along the eastern wall of the Lady Chapel are four altars. From North to South, these are dedicated to: St Matthew, the Blessed Virgin, St Andrew and St Peter. Because it is raised, the last one is sometimes nicknamed the "High Altar", as beneath it, is the access to the crypt. All were dedicated on 5th February 1523, when the grandson of the founder seems to have concluded that the chapel was finally suitable for the Eucharist.

Originally, there were six altars, just as there are today. The main altar was in front of the central pillar, beneath the figure of the Blessed Virgin, where the present main altar now stands. The sixth altar was in the crypt. These were the altars that were destroyed during the Reformation, but all have since been rebuilt.

Faces

Above each of the four altars in the Lady Chapel is a window. In the north-eastern corner of the northernmost window one can see a face. It is one of three faces. Its counterpart is on the southern corner of southernmost window.

Maize

Above this face is the famous carving of what is generally believed to be maize. To the right of the South door, on one of the lintels, is the carving of the aloe cactus. Both plants are believed to have come from North America and are said to have been unknown to the Western world at the time when the chapel was built, which occurred before the discovery of America by Christopher Columbus in 1492. This has led to the theory that Prince Henry St. Clair, the grandfather of the builder, sailed to the New World in 1398. A modern wooden chair sitting next to the Apprentice Pillar commemorates this idea.

It is the depiction of these plants that provides ammunition for those who believe that Henry St. Clair did indeed reach America. According to certain botanists, the depiction of the maize is accurate if it were a slightly immature plant. Others, however, are adamant that the plant is not maize, although they also have been unable to identify it.

The aloe cactus should be no surprise since this plant is not from North America, but is indigenous to Africa. Furthermore, the use of aloe was well-known in medieval times, used by herbalists as a purgative. Scotland was rich in such herbal gardens, including that of Holyrood Abbey, which was on the current site of Waverley Station in Edinburgh.

According to some theories, the depiction of what might possibly be maize is evidence for the possibility that Prince Henry St. Clair reached the New World one hundred years before Columbus.

Robert the Bruce's death mask

More or less in the middle of the East Wall is the so-called death mask of Robert the Bruce. Because the Sinclairs were no doubt most famous for their attempt to take Bruce's heart to Jerusalem, certain carvings in the chapel have been labelled as depictions of scenes from that "crusade". The truth, though, is that no-one knows whose head this is. Robert Cooper, Curator of the Museum and Library of the Grand Lodge of Scotland, states that the carving appears to be that of a young man and does not resemble any of the paintings or carvings depicting Robert the Bruce. *"It is supposed to be a copy of the death mask of Bruce but shows none of the marks of time, none of the scarring, none of the 'wear and tear' of 55 years."*

The death mask does resemble a similar strange head in the Abbey of St. Victor, in Marseilles, France. The catacombs of the abbey, dating from

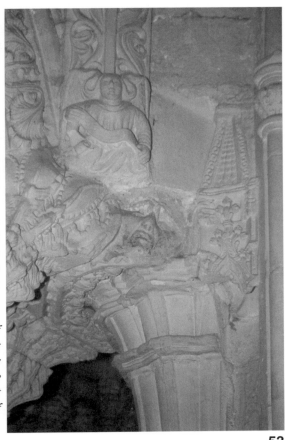

the 13th Century, are now known as the Chapelle St. Mauront, formerly belonging to the abbey and named after a bishop of Marseilles. They are the oldest Christian monuments found in Marseilles.

Inside the catacombs, in the chapel of St. Lazarus, there is a sculpture of a head resembling in outline and position (on top of a pillar) that of The Bruce. It dates from the Dark Ages and is therefore older than its Rosslyn twin. The people of Marseilles believe that it

Rosslyn Chapel is full of depictions of heads. This one, inside the Lady Chapel, is believed to be the death mask of Robert the Bruce (centre of photograph).

53

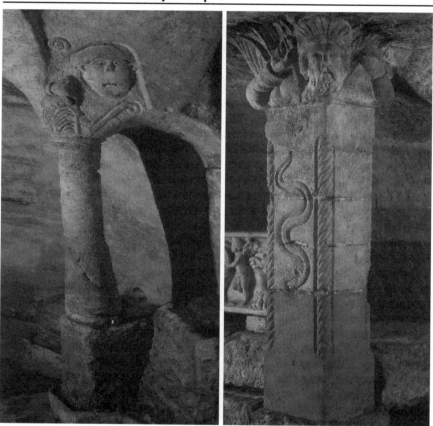

Certain features of Rosslyn Chapel can also be found in the catacombs of an abbey in Marseille, France. The death-mask, left, and the "serpents on the pillar", mimicking the Apprentice Pillar, right.

shows St. Lazarus and hence that part of the catacombs is named the "confessional of St. Lazarus". Opposite, on the left, one can see a pillar on which a serpent and the Tree of Life are depicted. This again echoes Rosslyn Chapel with the Apprentice Pillar, visibly depicting serpents and interpreted as the Tree of Life. William St. Clair travelled to France and several of the masons he employed were said to have come from Continental Europe, so it is highly likely that somehow this Marseilles church was the inspiration for the same features found in Rosslyn chapel.

Green Man

The Lady Chapel is divided into four sections: three that are easily accessible and one, forming the ceiling of the crypt access, which is not.

In the middle of East Wall hangs the most beautiful Green Man. This carving forms the exact centre of the Eastern wall, and hence would have been the focus of the congregation, that would also have faced East, as is clear from the setting of all the altars.

The Green Man, a Celtic motif, is depicted throughout the building. In fact, there are more than one hundred, making it the most often repeated depiction in the chapel. According to some, Rosslyn Chapel has the most number of carvings of the Green Man of any medieval structure. Peter Hill has noted that, starting at the main entrance, the faces of the Green Man appear to grow older as they go round, suggesting a progression from birth to old age.

In those days, the Green Man was quite a common feature in religious architecture. He is often carved as a powerful human figure covered in leaves and with shoots and tendrils sprouting from his mouth. He symbolises the fecund and regenerative power of Nature and illustrates its bond with Man. Therefore his changing in age as he goes around, growing old and becoming young again, seems a poignant illustration. Peter Hill has pointed out that in the medieval church, he was portrayed as the darker forces inherent in humans and symbolised chaos. In the Renaissance, he became a "breath of fresh air" and reminded people of

Rosslyn Chapel has more than one hundred depictions of the so-called "Green Man", a pagan symbol underlining the bond between Man and Nature.

their long-lost ancient roots. He became a folk-hero, suggesting Mankind had to let off steam occassionally.

As a forest guide, he is akin to the Greek Heracles and the Celtic god Smertrios. In Egypt, he would perhaps most likely be identified with Osiris. With the possibility that the Apprentice Pillar represents a tree, the 12th Century German epic Grendel comes to mind, where the Green Man appears as a wild man guarding a tree under which lie a lion, a bear, a boar and a dragon... reminiscent of the dragon/serpents encircling the foot of the Apprentice Pillar. He is definitely central to the message of Rosslyn, this "stone forest", where his presence is everywhere. Interpreted through modern eyes, the Green Man seems to warn us that mankind is supposed to live in unison with nature, not outside it, nor to act against it.

With the possibility that the Apprentice Pillar represents a tree, one should refer to the 12th Century German epic Grendel, where the Green Man appears as a wildman guarding a tree under which lie a lion, bear, boar and a dragon... reminiscent of the dragon/serpents encircling the foot of the Apprentice Pillar.

Arch angel hanging upside down
Almost at the centre of the Eastern Wall, is an angel suspended by a rope tied to his legs. The angel in this depiction is Shemhazai, although some have labelled him Lucifer. It is true that Shemhazai is a "fallen angel", but Lucifer was not hanging upside down from a rope, whereas Shemhazai is. The identification with the devil is equally erroneous. This is clearly an angel, unlike the devilish depiction that can be seen on the northern aisle.

Shemhazai's adventures are detailed in the Book of Enoch. Together with Azazel, he had asked God's permission to descend to Earth in an attempt to redeem Mankind. They arrived on Mount Hermon, and during their sojourn on this plane, Shemhazai fell in love with Ishtar, the goddess of love and war. Being what some would describe as "typically female", Ishtar would only respond to the acts of her suitor if he told her the secret name of God. According to the story, Ishtar used the power of the Word to ascend to heaven, to shine among the stars of the Pleiades. Now that he was single again, Shemhazai,in company with Azazel, decided to take an earthly woman, and procreate. They had two daughters each: Heyya and Aheyya, and Hiwwa and Hiija. The latter pair dreamed that they saw angels with axes cutting down the trees of a great garden. This is an interesting dream, for the Apprentice Pillar does look somewhat like a tree - in fact, being a pillar, it could be argued that it is a tree that has been been

cut by the roof - and the entire chapel breathes the atmosphere of a garden. In fact, the story of the dream is important, for it is soon after this dream that God informed Shemhazai and Azazel that He is going to redeem the world by sending a Flood. Shemhazai repented of his sins, but he was afraid to face God. So he suspended himself between heaven and Earth, hanging by a rope, head downwards because he was afraid to appear before God. Azazel, however, did not repent, and it is he that has acquired the reputation of the "fallen angel", as he led Mankind further astray.

It is curious that he should be depicted in a chapel dating from 1440, when the Book of Enoch was officially the story of myth and legend. However, the story of Shemhazai was known as early as the 11th Century in Jewish scholastic circles, which is probably from where the Sinclairs received their inspiration.

There were several "Watchers" who descended to Earth, and Shemhazai was their leader. This in itself is important enough to be depicted. More importantly, the Watchers imparted to Mankind certain advanced knowledge. In the words of author Andrew Collins, they *"had provided humankind with the forbidden arts and sciences of heaven"*. The specific knowledge that Shemhazai gave to Mankind was nothing less than exorcism and the somewhat more earthly cutting of roots.

While all of this was going on, Enoch was in Heaven talking to the "good angels". In the end, it fell to Enoch to inform the Fallen Angels of their doom. In his condemnation, God said to the Fallen Angels: *"You have been in heaven, and though*

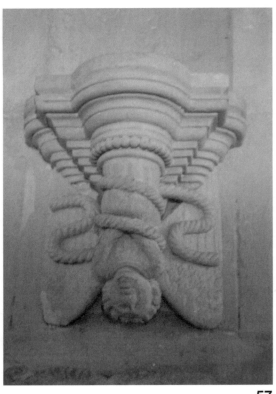

The archangel Shemhazai is depicted as hanging from the rope that connects heaven and earth. After leading Mankind into evil, he repented.

the hidden things had not yet been revealed to you, you know worthless mysteries, and in the hardness of your hearts you have recounted these to the women, and through these mysteries women and men work much evil on earth. Say to them therefore: You have no peace!"

As the mythologist Robert Graves has pointed out: The archangel Shemhazai is depicted as hanging from the rope that connects heaven and earth. After leading Mankind into evil, he repented.

Shemhazai, like Ishtar, has a celestial counterpart. That is the constellation Orion, in the Southern sky.

Angel indicating the breast and right calf
Further to the South, there are two angels, one indicating his knees with both his hands, the other, next to him, indicating his breast and right calf. The latter pose is said to be used in masonic rituals.

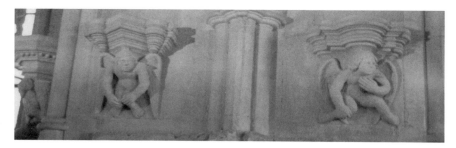

These two depictions inside the Lady Chapel are dear to the heart of the Freemasons, as the poses are also used during their masonic ceremonies.

Dance Macabre
On the rib from the North wall to the Master Mason's Pillar, inside the Lady Chapel, is a depiction of the so-called "Dance Macabre", the Dance of the Dead. It is one of the oldest and most complete depictions found in Europe and as such, it is a real art asset to the chapel. The dance was a popular theme, particularly in the latter half of the 15th Century, when the Church was being built. It is found elsewhere, including in frescoes in the Tower of London. Another example is in the Cimetière des Innocents in Paris, completed in 1424; but Rosslyn is believed to contain one of the earliest, if not the first, to be carved in stone.

There is another depiction of this dance, on the rib rising from the south-east wall corbel, over the stair of the Crypt, where there are eight figures. They are incomplete, the other half of the rib being filled with foliage.

The dance expresses the knowledge that the only certainty in life is

death - and seems to add that death does not distinguish between the ranks of rich and poor. The various figures, including a carpenter, a gardener, a child, a husband and a wife, are all flanked by a skeleton. Another recurring theme in the chapel is depictions of angels with scrolls, some of them open. According to some authors, this is a veiled reference to the presence of sacred scrolls underneath the chapel. But a more likely explanation is that it is another reference to the presence of "death". In Revelations 20:12, it states that *"I could see the dead, great and small, standing before the throne: and books were opened. Then another book was opened, the roll of the living. From what was written in these books the dead were judged upon the record of their deeds."* On the other side of the dance macabre are doves with olive leaves in their mouths. The olive leaf is an emblem of peace and therefore some have linked it with Redemption.

Cubes on Lady Chapel's ceiling

The ceiling of the Lady Chapel is decorated with "cubes". Some believe that these contain a musical code. Their belief is strengthened by the

fact that at the top of the pillars, there are depictions of angels playing various instruments, including the bagpipes. There is are several hundred of these cubes and there is variation between them, the pattern being repeated, but not monotonously so; hence the speculation that they might contain a musical dimension: the music of the angels. Although this is possible, if the symphony is ever to be played, it should be noted that that there is at least one cube missing, which will allow for some guesswork in the performance.

The distinct possibility, if not the actual fact, that Rosslyn Chapel was built by foreign workmen is underlined by the

The ceiling of the Lady Chapel is decorated by hundreds of cubes. Some researchers believe they are a symphony etched in stone, ready to be decoded and performed.

presence of bag-pipe playing angels sculpted in the French cathedrals. In the Northern French basilica of Avioth, built between 1225 and 1420, hence predating Rosslyn Chapel, there are depictions not only of Green Men, but also of a bag-pipe playing angel.

The style is so similar to Rosslyn Chapel's, that it cannot be coincidence; the inspiration for Rosslyn Chapel must definitely have come from Avioth, just like other ideas were taken from Marseilles, as we saw in the case of the "death mask" of Robert the Bruce. Slightly different bag-pipe playing sculptures have been found in many other cathedrals.

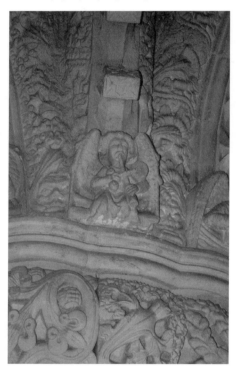

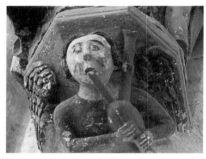

(above)
Sculptures of angels playing the bag-pipe on the Continent predate Rosslyn Chapel. This example is from Avioth, northern France.

(left)
In the Lady Chapel are depictions of several angels playing musical instruments, including the bag-pipes.

Central area (Choir)

1398 Arcadia chair
In the front of the church, one can normally find two wooden chairs. One of the chairs carries the image of a boat and is placed there because Henry St. Clair is believed to have been the real discoverer of America, almost one century before Christopher Columbus.

Virgin with Child

Most of the niches in the chapel are empty (as is best observed from within the choir), all of them demolished during the Reformation.

Above the main altar is a depiction of the Virgin of Child. It was a Victorian addition. The original statue there was destroyed during the Reformation and it is not known what was there before. Some have labelled this statue a "Black Madonna", but this is a misnomer. However, if there should ever have been a Black Madonna in the chapel, it might explain the specific, friendly alliance between the Sinclairs and the gypsies, who often stayed at Roslin and performed plays during the months of May and June. At that time, the gypsies were considered to be outlaws and at some point, the Sinclairs could no longer shield them from the

law. The gypsies are known to have a specific worship of Black Madonnas and Mary Magdalene, and their annual festival occurs at Saintes Marie de la Mer, in Southern France, where according to Christian legend, Mary Magdalene set foot on French soil and where, many years later, she would die.

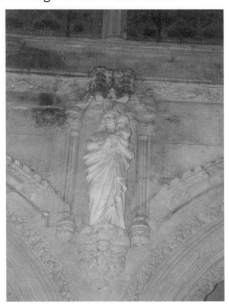

All the statues inside the chapel were destroyed during the Reformation. Few have been replaced, but the central statue, the Virgin with Child, has been, though it is unknown whether it replaces an original depiction of the Virgin with Child or a statue with another theme.

Main window

The main window of the East wall shows the Sinclair cross inside a square, inside a circle. Are we looking at a depiction of the "squaring of the circle", an old pre-occupation of many medieval alchemists and mystics? Note that this image's shadow (squared circle and engrailled cross) would be visible with the sun's rays inside Rosslyn Chapel every morning, but particularly on the equinoxes. One of them, the Autumn Equinox, September 21st, is also the feast day of St. Matthew, the patron saint of the chapel.

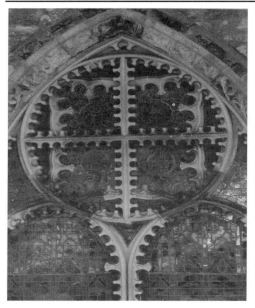

The main window of Rosslyn Chapel, in the Eastern wall, takes the form of a square inside a circle. Is it trying to portray an alchemical message?

Master Mason's Pillar

The choir is delineated by fourteen free-standing pillars. The height of each pillar including base and capital is exactly one quarter of the total height of the chapel, from the floor to the top of the high arched roof. Eleven pillars are identical. Three, marking the western end of the Lady Chapel, stand out and have been named the Master Mason's Pillar (northern), the Journeyman's Pillar (central) and the Apprentice's Pillar (southern). The Master Mason's Pillar forms the right pillar of the current entrance to the Lady Chapel. However, originally there was no railing between these pillars. It is the most northern of the three pillars, that have been given names.

On the top of the Master Mason's pillar, in the Choir, is the head of the murdered apprentice. According to Robert Brydon, the image has been altered from the original, which had a beard and a moustache. In medieval times, an apprentice stonemason was not allowed to sport a beard. Therefore, the head is, or was, that of the master mason. This makes more sense, as, after all, this is the pillar that was the one allegedly carved.

So what are we to make of the supposed master's head, that can be seen on top of the Apprentice Pillar? According to Tim Wallace-Murphy, a detailed analysis of his features reveals that the expression on the master's face is laughing.

Until the mid 19th Century, this pillar had been plastered over, to make it look like all other pillars, except for the Apprentice Pillar. Until this plastering was removed, the Masonic significance of the twin pillars was hidden.

The Master Mason's pillar, located in the north-eastern corner of the building, is said to be of specific significance to Freemasonry.

Journeyman's Pillar

The central pillar has received almost no attention. No mystery has been attached to it. Nevertheless, it might have an important position in the chapel. Together with the Master Mason's and the Apprentice Pillar, it forms a triad of pillars that were clearly set apart from the other eleven. Most accounts only mention the Master Mason's Pillar and the Apprentice Pillar. However, both operative and speculative masonry had three degrees: Apprentice, Entered Apprentice and Master Mason. The true significance of this pillar will be explained later.

Apprentice Pillar

The Apprentice Pillar is by far the most famous feature of the chapel. Eight dragons or serpents at the base are intertwined with foliage in four double spirals coming from their mouths. Each spiral is different from the others and winds upwards, 18 inches from its neighbour, bound to the column by ropes.

Built between the Master and the Apprentice Pillar, the central pillar, the so-called Journeyman Pillar, has received little attention, although its importance for Freemasons possibly outshines the other two pillars.

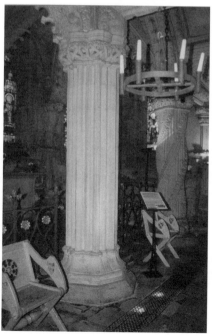

Its fame stems from its promotion in various books and legends connected with freemasonry. According to the legend of the pillar, the Master Mason had received the plan for a pillar of exquisite workmanship. Feeling unequal to the task until he had seen the original, the Master Mason travelled abroad. In his absence, his apprentice carved the pillar. Upon his return, consumed with envy and rage, the Master Mason struck his apprentice with a mallet and killed him. Or to use the words of Father Hay: *"This story is told us, that the master went abroad to see good patterns, but before his return his apprentice had built one pillar which exceeded all that he ever could do, or had seen, therefore he slew him; and he showed us the head of the apprentice on the wall with a gash in his forehead and his master's head opposite him."*

The tale bears a strong resemblance to another story of a murdered apprentice: the legend of Daidalos and his nephew Talos. Diodoros describes Daidalos as a master sculptor, architect and engineer. In Athens, he took Talos under his wing, but to his dismay, Talos was an even bigger genius: he invented the compass, the saw and the potter's wheel. Consumed with envy, Daidalos murdered Talos by throwing him from the top of the Acropolis. The Greek myth adds that when his mother Perdix, Daidalos' sister, learned the news, she hanged herself. Daidalos was caught, tried for murder, condemned, but escaped before the sentence was carried out. Still according to Diodoros, Daidalos arrived in Egypt, where he perfected his skills and won great acclaim from the Egyptians. Apparently, his legendary achievement was his design of a magnificent pylon, or gateway, in the Temple of Hephaistos (Ptah) in Memphis. From Memphis, Daidalos went to Crete, where he constructed the labyrinth for King Minos. Diodoros adds that Daidalos merely copied a design he had seen in Egypt, a Labyrinth visited by Herodotus, located in Hawara. In Greece, he became most famous for introducing sculpture, and he became identified as the stonemason par excellence. It seems clear that the "magnificent pylon" in the Temple of Ptah strongly resembles the story of the magnificent Apprentice Pillar, particularly when the rest of the story, of murdering the apprentice, is another nice coincidence.

Karen Ralls-MacLeod and Ian Robertson have pointed out that the story of the murdered apprentice is not unique to Rosslyn Chapel. It is also told in Rouen, in France, where the murderer is said to have been pardoned by the Vatican to allow the building work to be completed. In penance for his crime, he was to spend the rest of his life in a holy order carrying out good works. However, rather than a pillar, this story is focused on a rose window. As another version of the Rosslyn

The Apprentice Pillar is the most famous feature of Rosslyn Chapel. Freemasons from all over the world come to marvel at it, as it has attained a prominent role in the mythology of their organisation.

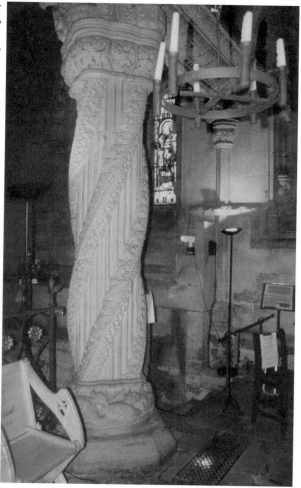

story also involves the master mason going to Rome, the Vatican connection is present in both. Since the modern Templars currently use Rosslyn as a centre for initiation, many have extrapolated that it was also used for certain initiations in the past. Authors have therefore pondered the idea that the murder might have occurred because the Apprentice had revealed too much in the design of his pillar, and that as a penalty for revealing the secrets of his secret brotherhood of stonemasons, he had to be executed.

Thompson found that the bishop of St. Andrews, to whose diocese Rosslyn belongs, was in Rome at the time when the chapel was approaching completion. He obtained a dispensation from the Pope to "reconcile Rosslyn", that is to cleanse it from the pollution of some deed of violence committed within its precincts. However, precise details of this "reconciliation" are not given. Even if the story of the murder is not factual, it was known as early as 1677, when Thomas Kirk heard it during his visit to the chapel - and therefore predates 1736 and the masonic Grand Lodge of Scotland. But although the story was known

at that time, in 1693, Slezer named the pillar as the "Prince's Pillar".

Freemasons have connected the story of the murdered apprentice to the story that is told within the Masonic Temples: the story of Hiram Abiff, the alleged builder of the Temple of Solomon, who was also murdered. In this scenario, the Master Mason's Pillar and the Apprentice Pillar are said to mimic Jachin and Boaz, the two central pillars of the masonic temple, based on the two central pillars of the Temple of Solomon.

The Apprentice Pillar has been subjected to various lunatic attacks. The wife of author Trevor Ravenscroft made a pilgrimage from Spain to Rosslyn, on horseback (quite an accomplishment as she was an untrained rider) and when she arrived there, she chained herself to the pillar, saying it contained the Grail which needed to be excavated. Only a few years ago, someone was apparently caught inside the church with drills and hammers, minutes before he tried to demolish the structure, as he believed it contained important secrets about the origins of Freemasonry.

Many people have noted various levels of symbolism attached to this pillar. The British author Tim Wallace-Murphy has compared it to Yggdrasil, the tree of Norse mythology, "the world Ash which binds together heaven, earth and hell", but also found in the Christian Tree of Life. As such, some believe that the tree might be a symbol for the Tree of Life, a concept from the Kaballah, the Jewish mystery cult, which was known as known to have been extremely popular in the Western medieval world. Steeped in tradition and symbolism, some people have speculated that the entire contents of the church need to be "read" from this perspective: an initiation into the secrets of the Kaballah. The central concept of the Kaballah is the Tree of Life, which contains a map of the paths to perfection. The downward path is called the Lightening Path, whereas the upward part is the Path of the Serpent. Interestingly, the dragons/serpents are at the bottom of the tree, perhaps an indication that the pillar is trying to convey they are beginning their upward journey, towards final enlightenment. If the eight dragons at the bottom are serpents, these could represent the Shamir, a rock-splitting serpent of Jewish mythology that helped King Solomon to build his temple without the use of iron to work the stones used in its construction.

It could also be the serpent of the Garden of Eden, with the Apprentice Pillar being the Tree of Knowledge. Are the Master Mason's and Apprentice Pillars perhaps the Tree of Life and the Tree of Knowledge? If it is the Yggdrasil, the creatures at its bottom would be the Nordic serpent, Nidhogg. This serpent lived beneath the great World Ash Tree, Yggdrasil, gnawing ceaselessly at its roots.

The bottom of the Apprentice Pillar shows eight dragons or serpents. They suggest a mythological dimension to the Apprentice Pillar, which to some is the symbol of the World Tree, which connects Heaven and Earth.

Another possible story that might be related - and which to my knowledge has so far never been linked to Rosslyn - is the story of Osiris. In a Greek rendition of the story, which was popularly known at the time of the building of the chapel, Osiris was locked in a mummy coffin by his brother Seth (the archetypal Satan) and cast adrift on the River Nile. The coffin was washed ashore and became lodged in a tree that grew around it. The tree was cut down and made into a pillar for use in the local palace, in the Lebanon. It was there that Isis, Osiris' sister and wife, found her husband for the first time. Though the sequence of events is sometimes different depending on the rendition, when Seth found out that she had discovered the body, he cut it into pieces and scattered them, even though he was too late, for by this time Isis had been able to impregnate herself by magical means from Osiris' dead body - a virgin conception. Of course, the Apprentice Pillar could be

67

interpreted as a tree, which has been made into a pillar. Therefore, the "Journeyman's pillar" might well be the "journeywoman", searching Osiris. In the choir, in the wall above this central pillar, is a depiction of the Virgin with Child, which is known to have an Egyptian counterpart: Isis with her's and Osiris' son, Horus, the future King of the World.

Tim Wallace-Murphy has associated the Green Man, depictions of which can be seen in such abundance in Rosslyn Chapel, with the Babylonian dying-and-rising god Tammuz, whose Egyptian counterpart is none other than Osiris. Indeed, in Egyptian depictions, Osiris is shown most frequently with a Green face.

So what precisely is the Apprentice Pillar? Probably the most likely explanation is that it is all of these. On a symbolic level, layers of symbolism are normally overlaid on top of each other.
However, some believe the Apprentice Pillar is a red herring. As guide Jim Munro has stated: *"The Apprentice Pillar is so famous that some believe its specific purpose is to attract all the attention and interest, so that no-one will look elsewhere, where the true mystery can be found."* So let us look further…

West wall

The West wall, both on the inside and outside, shows signs of work being abandoned before completion. It is clear, particularly in the south-western corner, that this was originally an arch leading to another part of the church. This is visible from the outside as well. But it seems that the founder's son Oliver decided to close this section off, so that the chapel could be considered "finished", though not in accordance with the original plan.

William St. Clair depiction
On the pillar that forms the corner of the Choir with the western wall, below the "Murdered Apprentice" carving, is the figure of what is believed to be William St. Clair, the founder of the chapel, holding a sword in his right hand. To the left are what some people think are cockle shells, though this identification is not clear. The depiction of the cockle is used as evidence that Rosslyn was on the pilgrimage route to Santiago de Compostella, which is an unsubstantiated allegation.

Heads of Master Mason and Murdered Apprentice (Choir)
In the south-west corner, is a head with a scar on the right temple. It has been claimed that this is the head of the Murdered Apprentice.

Examination of the apprentice's sculpture shows that once upon a time it did have a beard but that has been chiselled off. The scar on the right temple has re-inforced the identification of the Apprentice with Hiram Abif, the architect of King Solomon's Temple, who was wounded on his right temple by one of his murderers. It is this feature that has contributed to the Masonic fame of Rosslyn Chapel.

This carving of the "apprentice" is flanked by a carving reputed to be the head of the master mason (in the north-western corner). A tradition that dates back to before the foundation of the Grand Lodge, claims that he murdered the apprentice in a fit of jealous rage, because of the latter's superior skills as a mason.

East of the apprentice, under the next niche, is the head of a woman thought to be his mother. The carving is said to be weeping. According to legend, the workmen carved these heads when the walls had reached that height to symbolise the story of the murdered apprentice. Thus, we have the master mason, the apprentice and his mother. Are these echoes of Osiris, Isis and Horus... and should the central pillar's name be changed from Journeyman to Journeywoman?

There are, however, at the same height, on top of other pillars, other depictions of heads and angels. It is clear that these heads are just some among many who seem to have been singled out to be used in a story...with the blatant absence of any indication of how many other heads there are elsewhere in the chapel.

Southern aisle

Lintel next to Apprentice Pillar
There is only one original inscription in the whole building. Some people believe that this inscription is the key to decoding the entire structure. They wonder if the key might lie in its application to a magic square, a cipher often used by medieval alchemists in their search for Knowledge. Written in Latin, in Lombardic lettering, it reads: *"Forte est vinum. Fortior est rex. Fortiores sunt mulieres. Super omnia vincet veritas."* This translates as: *"Wine is strong, the king is stronger, women are even stronger, (but) truth conquers over all."* These words were written as a trial of wisdom by the three youths, who formed the bodyguard of King Darius. This link is strengthened by a depiction on the lintel connecting the Apprentice pillar to its western colleague. On the east corner, facing south, is a king being crowned. For at least a century, it has been believed that this king was Darius. In the west corner, there is a man playing bagpipes and directly underneath is a man reclining asleep, also representing Darius.

The only inscription inside the building is a Latin phrase from the Bible, related to the rebuilding of the Temple of Solomon, which is central in the mythology of Freemasonry.

The Belgian masonic historian Jacques Huyghebaert has pointed out that the connection between wine, kings, women and truth also occurs in a masonic degree called the Order of the Knights of the Red Cross of Babylon or the Order of the Babylonish Pass. In England, it is associated with the Royal Arch. It is linked to the Master Masons, where ceremonies take the candidate through the destruction of King Solomon's Temple, the seventy years of the Babylonian Captivity, and the ultimate return to the Holy Land to help, aid, and assist in the rebuilding of the Temple of the Most High.

To quote Jacques Huyghebaert: *"Its ritual is based upon the Book of Esdras (chapter 3, verse 4) and events which occurred during the captivity in Babylon... Zerubbabel, Prince of Judah, seeks an audience at the Palace in Babylon in order to obtain permission to rebuild the Temple of the Most High in Jerusalem."* The Prince is told that the request will only be granted if he can solve a riddle. He then asks "Which is the strongest, the Strength of wine, the Strength of the King or the Strength of Women?" The person who gives the wisest answer, which is "truth", becomes a kinsman, and reminds the King of the promise he had made, when ascending the throne, to rebuild the temple.

The image on the opposite page has been reproduced in numerous publications on Rosslyn Chapel. The reason for its inclusion is the obvious similarity between the depiction in the bottom right corner and the Apprentice Pillar. It is clear that the Apprentice Pillar was the model for this drawing. But what was the drawing of? It is indeed a very complex piece of work and most authors do not attempt an explanation. It was only when John Ritchie asked me to help him analyse it with a possible overlay on the floor plan of the chapel, that I gave it serious study.

An analysis revealed that the two depictions at the bottom were (left) the Tower of Babel and (right) the Apprentice Pillar. Both were accompanied by letters which could be formed into words: Zerubbabel and Raphodon. The search for Raphodon proved easiest: it was a name created in Scottish rite masonry and specifically for the initiation into the 15th degree, the Grade of the Knight of the East and of the Sword. The ritual dates from the first half of the 19th Century and is apparently no longer practiced, which might therefore be the reason why so few people were able to explain the drawing. The knight to be initiated in this degree is identified with Zerubbabel and in the ritual he is given the Sacred Word, Raphodon, which was allegedly a Scottish word, meaning "Lord of Raphe", which was said to be a place in Eastern Scotland. It was also said to mean "place of rest".

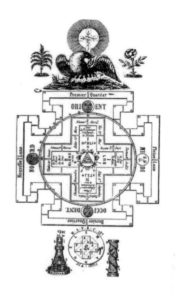

The inference of this drawing is therefore clear: the person making the drawing was familiar with the nature of the inscription and knew of its presence in Rosslyn Chapel. He used the chapel's imagery to construct another image, adding specific references, in particular the word Raphodon, which identifies it uniquely with Scottish rite masonry, and its 15th degree.

The rest of the drawing resembled a game board, with numbers and references suggesting that a path had to be walked, starting from Zerubbabel and ending at the Apprentice Pillar, Raphodon. In the ritual, it was indeed the initiate, identified with Zerubbabel, who only learned the sacred word at the end of his initiation. Was such a ceremony once held in Rosslyn Chapel? If so, it would mean that the Scottish rite masons used the chapel at one point. If not, it shows that at least some of them hoped this would become the case. Whatever the truth, it shows how in the 19th century, Masons, in their imagination, linked the chapel with their initiations - as they continue to do today.

It is said that in the 18th Century, Freemasons particularly in Continental Europe and America believed that the Scottish "Knight Masons" had

excavated the Temple of Solomon prior to the building of the second temple, which was labelled the Zerubbabel Temple. The story went that this was when they discovered the "Name of God" and the true secret of Freemasonry. It is generally agreed that the story was a ruse to create an interest in the Jacobite cause, a spurious campaign run by exiled Scots, who were supporting the claim of James VII to the throne. Nevertheless, it does show how Rosslyn Chapel was added into this equation. Again, when moves for Scottish independence and the monarchy rose, so did the importance of the chapel.

The inscription is far better evidence than the Master Mason and Apprentice Pillar that there is indeed a connection between the Temple of Solomon and Rosslyn. According to author Keith Laidler, Rosslyn is indeed a substitute for the Jerusalem monument, since, as he points out, at the time of the erection of the chapel, Jerusalem had been lost to the western world and only a copy could be visited. Laidler believes that there was the desire to recreate a substitute closer to home.

Seven Sins/Seven Virtues

On the eastern side of the lintel to the west of the Apprentice/ inscription lintel is the depiction of the Seven Virtues, whereas on the other (western) side, are the Seven Deadly Sins. All seven virtues are listed as well as the reward: St. Peter holding the keys to heaven.

Every carving in the chapel has been subjected to detailed analysis. To some, this depiction is of the knight Leslyn, who was, in modern mythology, related to the arrival of the Sinclair family to the region.

72

South Wall

"Knight Leslyn"
The window to the right of the door (furthest window west) has, on its eastern side, the depiction of a knight on horseback armed with a spear and behind him a figure holding a cross. Some believe this depicts William the Seemly, but as this is a mythical person of fairly modern invention, it is unlikely that it is he who is depicted there. Some refer to it as "two brothers on one horse" and believe it to be the knight Leslyn - the ancestor of the Leslie family, with the future queen Margaret riding pillion. The queen is carrying the symbolic representation of the relic known as the Holy Rood of Scotland, which was part of her dowry. As with so many small carvings, including the nearby angel holding a heart, it is often the theory that has led to the formulation of the observation, rather than vice versa. Others have interpreted the carving as two men on one horse, which was the sign of the Knights Templar.

"Veil of Veronica"
Another depiction along the South Wall shows the Veil of Veronica, said to have to have been used by St. Veronica to wipe the sweat off the face of Jesus when he was carrying the cross. The veil, also known as the Mandylion, was said to have retained the image of Christ. This "cloth" is different from the Turin Shroud, which is the one said to have covered Jesus in his tomb.

Ceiling

The roof is nine inches thick. It is the only barrel-vaulted roof of this size built in solid stone in Scotland. Fergusson, in Handbook of Architecture, suggested that this betrayed the origin of the architects: Northern Spain. The characteristics were prevalent in the churches of Burgos and Oviedo, and "the tunnel vault of the roof with only transverse ribs is such as those found in almost all the old churches in the south of France."
Inside, it is divided into five sections. From East to West, the first four segments show the flowers of creation open in all of their glory, particularly the rose of the Virgin Mary. In the Western section, there are the stars of the sky. Intermingled with these are a crescent moon, a small star, a dove, a sun and an open hand underneath. A possible explanation of the ceiling sequence is this: the first section (East): daises are for innocence; second section: lilies are for purity; third section: sunflowers for adoration; fourth section: roses for peace and love. Finally, the fifth section (West), with stars, the sun, the moon; they are

73

The "star section" of the ceiling not only contains stars, but also the sun, the moon, an open hand, as well as the face of Jesus.

for the heavens where you will find the dove of peace, Christ raising his hands in blessing and the cornucopia pouring its abundance of good things upon the Earth. Andrew Sinclair interpreted this last image as a symbol of the Grail: God's grace pouring forth into a bowl, or a cup or a crescent moon, i.e. the Grail. The dove carrying the host of the Eucharist in its beak is also linked to Grail imagery. This scene is reminiscent of the Parzival Grail romance, where a dove is said to bring the host and lay it upon the Grail.

Author Keith Laidler has given the following explanation to the Western section. The sun, which is depicted radiated, with an open hand underneath, is linked to the Aten symbol. The Aten is the Egyptian image of the sun, representing the solar disk. From it, several hands radiated down. It was particularly to the liking of Pharaoh Akhenaten, the rebel pharaoh, who tried to substitute the age-old Egyptian rituals with new ones, dedicated to Aten. The Aten symbol spreads its life-giving rays from the central disc. The sun disc is placed in the top right corner, the highest point on the structure.

Although there are a hand and a sun, there are also various other symbols that are not linked to the Aten. It may be true that it was only in the late 19th Century that traces of Akhenaten's existence and accurate depictions of the Aten symbol became known to the western world, but this might account for the inaccurate depiction of the Aten symbol. Laidler

therefore believes that its presence in Rosslyn is at least a suggestion that the creators of this carving were aware of knowledge that somehow had been kept throughout the ages. But it seems that a more likely explanation is that there is no connection to the Aten religion.

According to Knight and Lomas, the series of keystones running down its length are exactly as the ruins of Herod's Temple are described in Royal Arch Freemasonry. These include an angel with a sword and an angel with both hands uplifted. The "hand's up" sign indeed stems from a sign of recognition. It is said that when freemasons were in trouble, they would recognise each other, as the "hand's up" sign was originally a sign of surrender in masonic circles. Like some of the masonic phrases, this sign became common parlance - or in this case common gesture - later on.

Crypt (Sacristy)

The entrance to the main vault is in the south-east corner, next to the Apprentice Pillar. At one point, the badly worn steps leading to the crypt were difficult to manage, but they have now been replaced. The crypt is the opposite of the chapel, and is almost completely bare of decorations. It has, however, an excellent acoustical quality. Voices from inside the crypt can be heard throughout the chapel - sometimes resulting in eerie or spooky sound effects, depending on the tone of the voice...

An interesting aspect of the crypt is that despite being reached by stairs from the chapel, it is still above ground because of the slope on which it is built.

Like the chapel, the crypt has two doors, situated on the north and south side, opposite each other. They lead into other chambers, one being a modern addition. The one in the north wall goes to a small room, which some people believe has been used as a sacristy, a repository for relics and possibly the home for hermits. Some find the atmosphere in this room "creepy". The opening in the south wall now goes through into a modern annex, but originally it went outside and thus formed the entrance.

There are two stones in the crypt, along the north wall. One is a 17th Century guild stone, with a figure known as the "King of Terrors" carved on it. This was the so-called "Berserker", the man who would raise the battle cry. The other is a 13th Century Templar gravestone. Neither is native to the chapel; one coming from Old Pentland Cemetery.

It is said that the crypt was built by Lady Margaret Douglas, the first wife of Sir William St. Clair. Some have speculated the structure is older

On the walls of the crypt, which is believed to be slightly older than the chapel to which it connects, are drawings. They suggest that the crypt was used as an "office" for the masons, during the construction of the chapel.

than the chapel above. If this were the case, it was definitely built by a Sinclair, for in the arching across the ceiling of the crypt, the engrailed cross of the Sinclairs can be found. On the south wall, there is a fireplace. Although this may seem odd for a chapel, it has led certain people to believe that the crypt might have been the living quarters for a resident priest. Thompson has speculated that the funeral celebrations might have been performed here, rather than in the actual chapel. He described the crypt as follows: *"it seems to speak of death and decay, just as the richness and profusion of ornament in the Chapel above suggests the sense of life and beauty."* Alternatively, it might have served originally as the "office" for the masons working inside the chapel above. The latter seems quite likely. On the walls, the outlines of sculptural work has been drawn. It is said that these were working drawings for carvings etched in the chapel.

Masons' Marks
Beneath the outline of an arch is an almost circular mark. According to former caretaker Judith Fisken, this is reputed to indicate the presence of some hidden secret. Apparently she had first heard the story from her predecessor, and it has been confirmed many times by visiting Freemasons and Rosicrucians. However, she is unaware as to the nature of the secret.
There are also masonic drawings on the wall. There are masons' drawings on the north wall of the crypt, to the right of the doorway leading into the little room that was probably used as a sacristy. Note the pentagram which is probably a mason's mark. On the southern wall, the masons' drawings are etched to the left of the arched doorway.

St Peter's Key
The crypt is largely void of any decoration, apart from certain painted carvings, the paint being a modern addition. One is of St. Peter holding a key and the other is the angel which is called the "bleeding angel".
It is this depiction of St. Peter that has been the key to a world bestseller. St. Peter is holding a single key, rather than the usual bunch of keys to open the heavenly gates. But odd though the single key may be, authors Knight and Lomas believe that it is St. Peter's penetrating stare that draws one's attention. He is looking at the opposite wall in the vicinity of two angel carvings, one holding a shield on which the engrailed cross of the Sinclair family is displayed.

Knight and Lomas have termed this single key "the Hiram Key", also the title of their book, as they believe that this figure marks the entrance to the Scrolls vault (see Appendix). They claim that up until the completion

77

of the project, the west wall of the crypt was open, giving access to a labyrinth beyond. If true, this would lead beneath the present Lady Chapel, probably into the vaults. Radar analysis performed by Andrew Sinclair did discover the presence of a metallic shrine underneath the Lady Chapel.

It is a fact that something is buried in the crypt. John Slezer, at the end of the 17th Century in *Theatrum Scotiae*, writes that three princes of Orkney and nine barons of Rosslyn were buried here. As the founder of the chapel was the third and last prince of Orkney, it would mean his father and grandfather, who was the one believed by certain authors to have discovered America, were buried here. If true, this would mean that these were reburied here or that this section of the chapel is indeed older than that on top. The site for their burials is believed to be behind the north wall of the crypt and underneath the floor, which was relaid in the 19th Century as part of the restoration work before the rededication of 1862.

Bleeding Angel
The angel has become known as the "bleeding angel". The blood-like stains on this angel carving had gone undetected until July 1999, when an American tourist Ward L. Ginn, Jr brought the discovery to attention. To put it in his words: *"These are presumably water stains of a rust colour that resemble a bleeding wound on the right side of the forehead of the angel at the hairline. From the wound, 'blood' appears to flow down the right side of the face and then divides into two streams. One stream, the shortest, flows under the jaw and down the neck where it stops at the angel's bodice. The other longer stream flows from the hair*

onto the shoulder where it separates and flows downward in two streams disappearing beneath the Sinclair

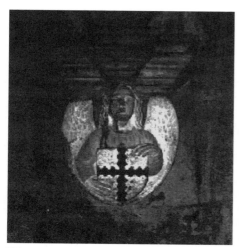

Over the past few years, a further mystery has appeared in the crypt. Instead of a bleeding Madonna, Rosslyn Chapel's crypt seems to possess a "bleeding angel", even though the bleeding is not continuous and might only have occurred once, leaving the staining behind. Exactly where the red stained flow of water - if that is what it looks like - originated from is unknown.

shield the angel is holding." A strange coincidence is that the wound on the angel's forehead is in the same position as the alleged wound on the temple of a carved head in the upper chapel, reputed to be the murdered apprentice, who, legend claims, carved the architectural centrepiece of Rosslyn Chapel, the Apprentice Pillar.

The Vaults

A large mystery surrounds the vaults. As the vaults are the only part of the chapel that is closed, not only to visitors but to everybody, they, together with the Apprentice Pillar, have become the favourite locations where it is suspected that "the secret" is hidden. It is a clever ploy of the cottage authors to make sure their theories are never destroyed - until one day when the vaults are opened again, as they were occasionally until some centuries ago, when the Sinclairs were no longer buried inside the vault.

An Englishman employed by the Government to spy on the Jacobites revealed that the tomb, which had fired the imagination of conspiracy theorists across the globe, contained nothing more than old bones.

John Slezer's story appeared in *An Account of the Chapel of Roslin*, a book written in 1774: *"At the foot of the third and fourth pillars, between them and the north wall, there is a large flagstone that covers the opening of the vault which is the burial place of the family of Roslin"*, he wrote. *"The vault is so dry*

Despite much mystery surrounding them, the entrance to the vaults is known and easily visible to all observers.

79

that their bodies have been found entire after 80 years and as fresh as when first buried of old in their armour, without any coffin." The entrance to the vaults is, in spite of the surrounding mystery, very obvious: it is one giant slab. The large stone stands out amongst its colleagues, as might be expected since, for many centuries, it had to be lifted and replaced for the funeral of each Sinclair. Evidence of mortar and repairs are particularly visible on the southern side of the slab.

As Sir Walter Scott himself pointed out, there were twenty lords of St. Clair buried in the chapel. All but one of the male members of that family were interred not in a coffin but encased only in their armour. Father Hay states that when the vaults were opened for the burial of his stepfather, Sir James St. Clair, the body of Sir William St. Clair, buried 3rd September 1650, who had died at the battle of Dunbar, seemed to be complete. *"But when they came to touch his body it fell into dust; he was lying in his armour, with a red velvet cap on his head, on a flat stone."* Sir James St. Clair was the first to be buried in a coffin, rather than being displayed on a flat stone in armour, as had previously been the custom. Apparently, the coffin burial caused the resentment of King James VII and *"several other persons well versed in antiquity, to whom my mother would not hearken, thinking it beggarly to be buried after that manner"* (i.e. in armour), according to Father Hay.

The last burial inside the vault happened in 1778, when the last male heir of the line of Sinclairs, and the first Grand Master of Scottish Freemasonry, was buried, at the age of 78. He was buried with full Masonic honours.

In 1897, Thompson described the vaults as *"built of polished ashlar...they are divided into compartments and run east to west, with a wall running down the centre of the Chapel".*

Under the initiative of Niven Sinclair, three separate non-invasive radar scans were carried out in recent years. The major one was carried out under the aegis of the Mechanical Engineering Department of Edinburgh University. It was discovered that three steep stone steps led to the vault. In the words of Andrew Sinclair: *"It was small, the space between the foundations of two pillars. It was arched with stone, but access to the main vaults beyond had been sealed by a thick wall of stone masonry, perfectly shaped beneath the arch."*

In *The Daily Mail* of 9th December 2000, Andrew Sinclair wrote: *"The groundscan had shown two stairways leading beneath the slabs. Laboriously, one set of flagstones was lifted, rubble was cleared, and three steep stone steps were exposed leading to a vault below. I was the first to squirm into this secret chamber. It was small, comprising the*

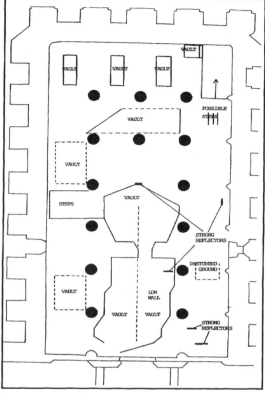

The author Andrew Sinclair carried out groundscans of the Chapel, in an effort to map the locations of the vaults. He discovered the vaults took up large portions of the "underworld" of the chapel.

space between the foundation of two pillars. It was arched with stone, but access to the main vaults beyond had been sealed by a thick wall of masonry. The soggy wood from three coffins had been stacked against the blocking wall. Sifting through the debris I found human bones and the fragments of two skulls. Two rusty coffin handles, a mason's whetstone - and a simple oak bowl. That is what the original grail from the Last Supper would have been - a wooden platter passed by Jesus Christ, in his divine simplicity, to his poor apostles. But the one I held in my hands had no doubt been left by the same medieval mason who had discarded his whetstone. We lifted the slabs to a second staircase, supposing they might lead down to the shrine, only to discover many feet of earth and sand. This was a bitter disappointment. We had not realised how deep the lower vaults lay, and how much in fill was packed above them. Drills were called in to force through a narrow hole down which we would lower an industrial endoscope - a tiny camera at the end of a glass tube, as flexible as the head of a striking snake, which could point at buried objects under the light of a laser beam. It could operate to a depth of more than thirty feet and transmit colour images to our monitor screen above ground. As we drilled deeper and deeper into the centre of the Chapel we struck 3 feet of solid stone. Finally the drill bit broke through into open space - only to jam fast. Only after working day and night did we manage to remove the drill and introduce the protective pipe through which we could drop the endoscope. At

last, it seemed that we were about to see what lay inside the chamber of the Knights. But the hidden shrine was still not ready to give up its secrets. Again and again we pushed the pipe down the drillhole. Again and again, infill poured down and blocked it. All we ever saw on our monitor was dust and detritus clogging up the end of the pipe. After a week of work we were defeated."

Upon the capital of the pillar next to the vault entrance and closest to the north entrance, are two angels removing the stone from the entrance to the tomb of Jesus: an apt depiction close to the entrance of the vault of the dead Sinclairs. There are also two monstrous beasts, representing, perhaps, death and hell.

Alleged William St Clair tomb (north aisle)

Ilt seems that one Sinclair is missing from the vaults: the founder himself. On the floor in the north aisle, next to the vault, and between the next two pillars towards the east, near the altar, an incised slab can be seen. It depicts a knight in armour, his hands in prayer, with a dog at his feet, and on each side of his head a small shield, on which there is a lion rampant.

Popular accounts say that this is the burial site of William St. Clair, the forefather of the builder, who took the heart of Robert the Bruce to Jerusalem. But he died more than one hundred years before the construction of the chapel. Jackie Queally adds some evidence to it being William, suggesting the dog might refer to his dogs Help and Hold, who aided him in winning the famous wager against the Bruce.

However, unless he was re-interred here, a more likely explanation might be that this marks the burial site of the chapel's buikder, William St. Clair, whose tomb was set apart from all the others, and who would be interred inside the vaults later on. As it now stands, the knight appears to guard the entrance to the vault, but is, at the same time, still present inside the chapel, rather than being an invisible presence in the vaults.

The alleged tomb of the builder of the chapel, William St. Clair, is believed to be outside of the vaults. Some believe he is next to the vault's entrance.

Niven Sinclair decided to have a "Holy Rood" made, to realise his belief that somewhere inside or underneath the chapel, the true "Holy Rood", brought to Scotland by Queen Margaret in the 11th Century, remains hidden.

Thompson believes that as there is a shield of William St. Clair with that of his wife on a north wall pillar, this assumption is quite likely. But, in truth, it could be the tomb of anyone, including the father-in-law of the builder and the grandson of Robert the Bruce, Alexander Sutherland of Dunbeath, who in his will expressed a desire to be buried inside the chapel.

Baptistery

The Baptistery is a Victorian addition, from 1882, and therefore little mystery can be found in it. Knight and Lomas have described it as an "invasive carbuncle" and have even - hopefully tongue in cheek - asked for its removal from the chapel! It is with the building of this extension in particular that Rosslyn Chapel attained a more "conventional appearance", for at the same time, new stained glass windows were added as well as a statue of the Madonna and Child.
A staircase on the left-hand side of the door (which can be seen as you walk in) leads to the Hamilton organ. But the most prominent feature is the baptistery on the ground floor.

Holy Rood Cross
This is a dark wooden cross which is located most frequently in the baptistery, although sometimes it sits on one of the altars in the Lady Chapel. It was made on instructions of Niven Sinclair and is said to represent the Holy Rood. Niven Sinclair gave it to the chapel, as he believes the true Holy Rood rests somewhere within.
Author Keith Laidler, however, has speculated hugely regarding this cross, unaware of its modern origins. He writes: *"Only the head of Jesus is displayed, without the crown of thorns, but with a cloth or*

83

*leather headband around his head. His body is missing. This is quite intriguing, for there is no tradition in Christian iconography to place Christ's disembodied head upon the cross at the intersection of the arms: it is possibly unique to Rosslyn. "*In the end, he concluded: *"Here, in the chapel where I suspected the embalmed head of Jesus was hidden, was the world's only crucifix upon which Jesus was depicted as a disembodied head. "*Unfortunately, the depiction is not at all "original", i.e. native, to the chapel, and its message is quite different from the one interpreted by Laidler, who seems to have turned this discovery into one of the cornerstones of his theory.

8.2 Ground plan

Rosslyn Chapel is 35 feet by 69 feet (ca. 10.7 metres by 21 metres), with a roof height of 44 feet (13.4 metres) and is aligned to the four cardinal points. By all accounts, it is small, even though it exudes an air of grandeur. The official version has it that Rosslyn Chapel in its current state was the first stage of a much larger Collegiate Church, which, however, was never built. The choir, which is all that was completed, stands on thirteen pillars that form an arcade of twelve pointed arches. A fourteenth pillar between the penultimate pair at the east end of the chapel form a three-pillared division between the nave and the Lady Chapel which extends over the whole width of the building. According to Josephus, the arts of astronomy and music were carved on two pillars by Adam's son Seth. It is said that this knowledge was passed on in masonic tradition. Zoroaster was likewise believed to have inscribed the seven liberal arts on fourteen pillars, half of brass and half of baked brick. These pillars and those of the Greek god Hermes on which all true knowledge was inscribed, were said to have been rediscovered by Hermes Trismegistus, the founder of alchemy and the Hermetic doctrine.

According to authors Knight and Lomas, the fourteen pillars have been arranged so that the eastern eight of them, including "Boaz" and "Jachin", are laid out in the form of a Triple Tau. "Tau" is the last letter of the Hebrew Alphabet and, like the Greek omega, signifies the end of something.
Knight and Lomas, apparently following the research of journalist Robert Brydon, have compared the layout of the building with Temple of Solomon in Jerusalem. They write: *"...they were identical, with the two pillars of Boaz and Jachin perfectly in place, and a massive engrailed Sinclair cross on the ceiling even pointed down at the exact spot where the 'Holy of Holies' was kept in the Jerusalem Temple. "*They argue that the oversized west wall was *"a copy of the ruined remains of the*

Herodian structure and not, as the standard theory suggests, an aborted attempt to build a huge collegiate church. "They add that the superstructure above ground level and forward of the west wall is an interpretation of the prophet Ezechiel's vision of the heavenly Jerusalem. Knight and Lomas are both freemasons and they have stated that the formation and the proportions of the chapel are exactly as stated in the intiaition ritual of the Royal Arch degree of Freemasonry, which describes an excavation of the Temple of Herod: *"Early this*

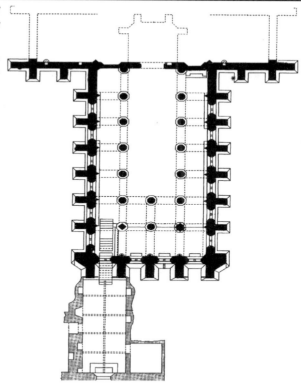

morning on resuming our labours we discovered a pair of pillars of exquisite beauty and symmetry: proceeding with our work, we discovered six other pairs of equal beauty which from their situation, appeared to be the remains of the subterranean gallery leading to the Most Holy Place. " It is because of such symbolism, in a Church dating from the 15th Century, two centuries before the official formation of Masonry, that Rosslyn Chapel has been labelled by some as the prime mover of Freemasonry.

Evidence of the foundations for an extension to the west has been found, first by excavations in the 19th Century and later by groundscans in the 1980s. The western wall is definitely unfinished. In its present state, the Temple of Solomon and Rosslyn Chapel do not correlate perfectly in its western section. But, interestingly enough, what remains there are show that, if it had been built, it would be comparable with the plan of the Temple of Solomon.

In the 19th Century, architects Sir Daniel Wilson and Andrew Kerr noted

85

a strong resemblance to Glasgow Cathedral. They believe that the "peculiar feature of the central pillars in the east end", i.e. the three pillars delineating the Lady Chapel - those that have been linked to Freemasonry, is very similar to the Cathedral's plan.

The first church on the site where Glasgow Cathedral now stands was probably founded around 600 AD by St. Kentigern ("great chief"), who is better known by his nickname, St. Mungo ("dear one"). King David I founded the diocese of Glasgow about 1114 and the first cathedral was dedicated in 1136. Nothing remains of this building. Most of the present building dates from 1240 and was finished about 1300 - roughly a century and a half before the construction of Rosslyn Chapel. The construction was the work of Bishop Bondington, who wanted to make the eastern arm the setting for the shrine of St. Kentigern and for the services of the cathedral clergy.

Indeed, the pillars in both the choir of Glasgow Cathedral and in Rosslyn Chapel are laid out identically - not just the three "masonic pillars", but all fourteen pillars. The altars are situated in the same places, including four in the "Lady Chapel", even though the Lady Chapel of Glasgow Cathedral is located elsewhere. (We will refer to it as "Pseudo LadyChapel".) Furthermore, the Pseudo Lady Chapel of the Cathedral is also raised from the floor of the choir, but with three steps, rather than one.

Unlike Rosslyn, the "masonic pillars" in the Cathedral are not set out from the rest. The galleries in Glasgow Cathedral, inspired by those of Rievaulx Abbey in Yorkshire, are different from Rosslyn Chapel, but this is quite normal, bearing in mind the difference in scale of both buildings. The plan of the fourteen pillars is known to have been developed in England in the early 12th Century, when it was taken up by Cistercian monks in eastern France as a relatively simple way of providing space for additional altars. It was then reintroduced into England for a number of Cistercian churches, such as Byland Abbey in Yorkshire and from there the idea may have been imported for the Scottish Cistercian church of Newbattle Abbey, near Rosslyn. Newbattle Abbey was also founded by King David I, as a daughter-house of Melrose Abbey. The monks there were the first to work the local coal seams and subsequently exploit the coal for the salt-panning industry. Their industrious work rapidly made their abbey one of the most powerful in the land. It is known that Bondington was an admirer of the Cistercians, choosing to be buried at their chief house at Melrose, where the heart of Robert the Bruce would later be buried.

The ground plan is the closest connection anyone can make between the Templars and Rosslyn Chapel: Rievaulx Abbey was founded directly

As the West wall was left unfinished, it offers a view of the interior and how the building was erected.

by St. Bernard of Clairvaux, as part of the missionary effort to bring Christianity to western Europe. Twelve Clairvaux monks came to Rievaulx in 1132, and from these modest beginnings sprang one of the wealthiest monasteries of medieval England and the first Cistercian monastery in the North. Bernard of Clairvaux was pivotal in the foundation of the Knights Templar, who, in the Rule of the Order as written by Bernard himself, were seen as the military arm of the Cistercian Order. Currently on display in the crypt of Glasgow Cathedral are carvings since removed from the main cathedral. These include mysterious faces, and also depictions of the Green Man. Furthermore, like Rosslyn Chapel, the Cathedral stands on a hill.

So it seems that Wilson and Kerr were indeed correct in their belief that William St. Clair may have been inspired by this Cathedral. However, there are also differences: Rosslyn's walls are intricately decorated, whereas those of the Cathedral are mostly plain. But as it is accepted that Glasgow's ground plan imitates that of Newbattle Abbey, one wonders whether this building might not have been a more likely source of inspiration, being so close to Rosslyn.

8.3 Exterior

A canopy has been placed over the roof. As a result of this, visitors can climb up and see the sculptures on the roof, including a beehive. Although there are views of the surrounding area and the roof from this canopy, which is expected to remain in place until 2005, it definitely obstructs the view of the exterior of the chapel. However, this is not a major loss

87

The West Wall was never finished as William St. Clair died before its completion. His son merely made the construction water-tight, blocking up the openings.

as the outside carvings have severe deterioration because of weathering. Furthermore, the outside features that are noteworthy are still visible in spite of the presence of the canopy. The gargoyles at the entrance are a reminder of the lower nature of mankind and of the evil spirits who taunt and lead astray. By making them into water spouts, they become the symbol of cleansing, showing the difference between the "wicked" world and the "sacred"chapel.

West Wall

The West Wall is definitely the most impressive feature. When comparing the joints of the baptistery with the West Wall, it is clear that the former was a later addition. On both sides of the baptistery one can find the so-called "transept" and also evidence of an altar with a piscina. Next to each side is the clearest sign of its abandonment. What would originally have been an opening has instead been solidly built up. The most likely scenario is that Oliver Sinclair wanted to see the chapel completed as soon as possible and therefore decided not to build the final phase of the west end, but merely block it up and leave it unfinished. As the west wall was left unfinished, it offers a view of the interior and of how the building was erected. Looking up, one can clearly see how the walls were constructed on the south side, where stones that would normally have been shielded inside the wall at the end have been exposed to the elements for more than 500 years.

The wall has become the subject of debate, particularly the contention of Knight and Lomas that this wall was built to resemble the walls of the Temple of Solomon in Jerusalem. Professor Philip Davies, a biblical and Dead Sea Scroll scholar, agrees with Knight and Lomas' assertion that this west wall is Herodian in style. Professor Graham Auld of Edinburgh University has seconded that opinion.

Dr. Jack Miller, head of studies in geology from Cambridge University, observed that the west wall could not possibly be part of a larger structure, as the stones are not tied into the main building. *"Whilst those buttresses have visual integrity, they have no structural integrity... Any attempt to build further would have resulted in a collapse."* He further added: *"The stones of the unfinished ends have been chiselled to make them look worn, like a ruin... If the builders had stopped work because they had run out of money or just got fed up, they would have left nice square-edged stonework, but these stones have been deliberately worked to appear damaged - just like a ruin. These stones haven't weathered like that... they were cut to look like a ruined wall."* The stones, he also argues, are of exactly the same stratum as that found in Jerusalem. At the top of the west wall, there is a beehive, constructed by the builders. Its opening is via a flower. With the erection of the scaffolding in the 1990s, the beehive was destroyed.

South-west Corner

On the lower frame of the window in the south-west corner of the chapel, which is difficult to reach because of the canopy, there is a carving that, according to Knight and Lomas, seems to be depicting a Freemasonic First Degree initiation. The carving is weather-worn and about thirty centimetres high.

Knight and Lomas' interpretation is thus: both figures are on their knees, and the apprentice is holding what could be a bible at his side. The other figure is bearded and is claimed to be a Templar knight. To quote Robert Lomas: *"The figure shows a man kneeling between two pillars. He is blindfolded and has a running noose about his neck. His feet are in a strange and unnatural posture and in his left hand he holds a bible. The end of the rope about his neck is held by*

According to Knight and Lomas, this carving on the outside wall of the chapel shows the initiation of a First Degree Mason.

another man who is wearing the mantle of a Knight Templar." However, as the sculpture is outdoors, it is very eroded. What is usually claimed to be a Templar cross on his chest is not clear enough to be convincing. It might be the top of a cross or it might not. When someone is initiated into Freemasonry, the candidate wears rough white clothing, folded back to reveal particular parts of the body. The candidate is blindfolded and has a running noose about his neck. He stands before the two pillars of the Masonic Lodge, Jachin and Boaz. Lomas lists the following points of similarity between the carving and the Masonic ceremony:

1. The man is blindfolded. This is unusual in medieval statues and the only other example of it is the figure of blind justice. There is no other blindfold figure carved in Rosslyn.

2. The man is kneeling. This is fairly common in medieval carvings and there are other kneeling figures in Rosslyn.

3. The man is holding a bible in his left hand. There are a number of other carvings showing figures holding books or scrolls within Rosslyn.

4. The man has a noose about his neck. There are few known figures of the period showing nooses about their necks. The best known is the statue called "The Dying Gaul". There is one other figure in Rosslyn that bears a noose. That is the figure of the hanged man, who represents the angel Shemhazai, whose sins caused God to send the Flood and who was so afraid to face God that he hung himself between heaven and earth with his face away from God. Shemhazai is carved with a noose about his feet but there is no other noose carved in Rosslyn.

5. The man has his feet in the posture that is still used today by Masonic candidates. This is a very unusual position and does not occur in any other carvings in Rosslyn.

6. The ceremony is being carried out between two pillars as it is in a Masonic Lodge. Pillars figure in a lot of the carvings at Rosslyn.

7. The noose is being held by a man clearly dressed as a Templar. There are many Templar symbols and images of Templars carved in Rosslyn.

As the carving is very weather-worn, it is difficult to substantiate Knight and Lomas' claim.

East Wall
Along the East wall, there was seating, a feature not present on the other sides of the chapel. As churches were the hub of social life before and after services (which were held most frequently in the morning), it seems that the East wall was chosen so that those waiting could catch the light - and warmth - of the morning sun. The roof of the structure onto which you are looking is the crypt that, as already mentioned, is situated above ground, because of the slope of the hill.

In the second window from the North, there is a head just below the top of the window. Such heads - as well as Green Men - can also be located elsewhere. It shows that the theme from the interior was continued on the outside.

South-western corner of grounds
An imposing grave (the tallest), more than three metres high, stands in the south-western corner of the grounds. It is the last resting-place of the Fourth Earl of Rosslyn, the Grand Master. He added the baptistery to the chapel, who wanted to be buried on that exact spot.
Being a poet, he had selected the following of his own verses to be inscribed on his gravestone: *"Safe, safe at last from doubt, from storm, from strife. Moored in the depth's of Christ's unfathomed grave."* This is an intriguing reference, for according to Christian teachings, Christ, being resurrected, therefore has no grave.
The verse continues: *"With spirits of just, with dear ones lost and found again, this strange ineffable life is Life Eternal; Death has here no place and they are welcome best who suffered most."*

8.4 Around the Chapel

One story says that shortly after the release of *The Hiram Key*, the book written by Knight and Lomas, a French company bought the land between the chapel and Rosslyn Castle. Under the guise of an "archaeological dig", they brought in caisson-drilling rigs and began to savage the ground beneath the chapel, with the intent of digging sideways into the ground underneath the chapel itself. The retaining wall supporting the chapel began to give way, threatening the entire

structure with collapse. Emergency legislation by Scotland put a preservation order on that land and every significant site in the country. Unfortunately, this is not true. The land was bought in 1998 by a Trust, called The Gardener's Brae Trust (Gardener's Brae being the name of the land around the Chapel), which was set up by four Friends of Rosslyn, using money provided by the Friends. The land was never owned by a French company - nor was there any emergency legislation.

St Matthew's Church ruins and Well

Rosslyn Chapel is dedicated to St. Matthew. It is, however, not the first chapel on the site. An earlier church dedicated to that saint stood below and to the south-west of the present chapel in what is now the village graveyard. The date of its construction is unknown. There are now only two buttresses are left at the lower end of the graveyard. As late as 1831, portions of the 86 gables still existed. At that time the length of the church was thought to have been 60 feet long.

According to Andrew Sinclair, black Augustinian monks settled in Roslin in the 12th Century, in the Church of St. Matthew. The church was still used when Rosslyn Chapel was built. In fact, it was in this church that the builder, William St. Clair, had his marriage annulled - and where he remarried his wife after the Pope granted a dispensation.

At the Disruption of the Church of Scotland in 1843, Rev. David Brown of Roslin Parish Church left the Established Church with the majority of the congregation and preached in the cemetery for eighteen successive Sabbaths until a church could be built for him. This would be the first Free Church of Roslin. The Masons, who, have a lodge in Roslin village, as they have almost everywhere in Scotland, have taken over that building, which is now their Masonic Hall.

Just below the old churchyard is St. Matthew's Well. The legend goes that when Queen Margaret poured the blood of St. Catherine of Alexandria on the ground, a healing well gushed forth from that spot. It is this story that is linked with the arrival of the Sinclairs as keepers of the land, but it has been shown that this legend has no basis in reality. Furthermore, it is known that the well is far older than the arrival of Margaret in Scotland.

The well was the village's water supply until the end of the 19th Century, when the water was found to be contaminated, probably from the industry in the area.

How to get there
Between the visitors' car park
and the chapel, take the road
down the hill, which reaches the
cemetery. The old cemetery is
on the left side, the new one of
the right side. It is in the old
cemetery that the Well and
church ruins once stood.

Rosslyn Castle
The oldest parts of the present
castle date from 1304, when
William St. Clair was shown the
defensive qualities of the land
and suggested that the castle be
located there, as it was surroun-
ded on three sides by the river
Esk. It is assumed that the
location of the castle was
elsewhere before, but when the
first castle was built, or where it
was built, is unknown. Oliver

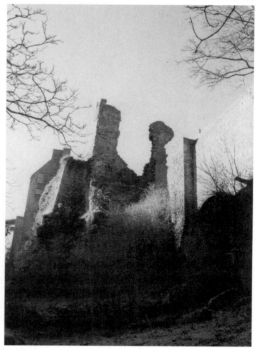

and Boyd's *Scottish Tourist*, published in 1852, states: *"The first castle of
Roslin was called the Maiden castle, some vestiges of the foundation of
which can be traced within a bend of the Esk at a short distance."*

The Castle has been overshadowed by the splendour of the later built
Chapel. The William St Clair who built the chapel was also responsible
for a large part of the present Castle, to which he made several
improvements and enlargements. When the castle was beleaguered in
1650, using gunpowder, Cromwell's forces, under the leadership of
General Monck, merely placed their cannon on the other side of the
river and battered the Castle to the ground.

The castle is shrouded in mystery, particularly a story regarding its cellars.
Sir Walter Scott wrote that *"From the inner edge of the outer door, At
thirty feet of old Scotch measure, The passage there, that's made secure,
Leads to the holy Roslin treasure."*
James Jackson, in *Historical Tales of Roslin Castle from the invasion of
Edward I of England to the Death of Mary, Queen of Scots*, wrote that
precious manuscripts were hidden in a sealed room in the cellar of the
castle. General Count Poli, an Italian, tried to access these and arrived in

93

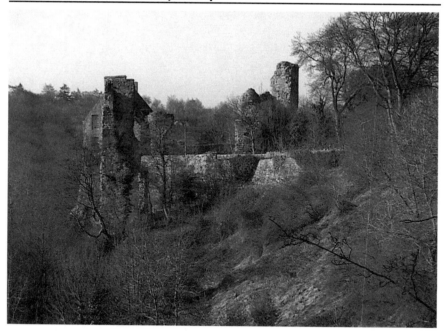

1834 with an ancient volume that supposedly contained the key to finding this cellar vault.

The Castle was also the location where the library of the Sinclairs was stored. It was in 1447 that disaster almost struck. In the words of Father Hay: *"About this time [1447] there was a fire in the square keep by occasion of which the occupants were forced to flee the building. The Prince's chaplain seeing this, and remembering all of his master's writing, passed to the head of the dungeon where they all were, and threw out four great trunks where they were. The news of the fire coming to the Prince through the lamentable cries of the ladies and gentlewomen, and the sight thereof coming to his view in the place where he stood upon Colledge Hill, he was sorry for nothing but the loss of his Charters and other writings; but when the chaplain who had saved himself by coming down the bell rope tied to a beam, declared how his Charters and Writts were all saved, he became cheerful and went to recomfort his Princess and the Ladies."* This incident has been used by some researchers to show how important those documents were. However, what is less well reported is the cause of the fire: a maid searching for little puppies accidently lit a bed with the flame of the candle.

How to get there
Between the visitors' car park and the chapel, take the road down the hill, which reaches the cemetery. Walk along the path that bisects the old cemetery. After about a hundred metres, you will reach the Castle. The gate might be closed, but should not be locked. The forecourt of the castle is open for visits. The main wall has an entrance... which is now an exit. If you walk through it, you will see how impressive it originally looked from the outside.

Lynn
Rosslyn Castle is built on top of a promontory. The river Esk makes a sharp U-turn around it. At the U-turn, the "Lynn", the "waterfall" can be found. The river hits a tremendous wall of stone and almost has to reverse its course. Huge boulders of rock create an idyllic, private setting. One can only wonder whether this was the Sinclairs' favourite place to "skinny dip". According to tradition, it is this feature that gave Rosslyn its name.

How to get there
Between the visitors' car park and the chapel, take the road down the hill, which reaches the cemetery. Walk along the path that bisects the old cemetery. After about a hundred metres, you will reach the Castle. In front of the gates, there are steps leading down on the right-hand side. They will take you around the bottom of the castle. Walk along the river, over a bridge. There is a small path to the lynn, but it is best to try and stay as close as possible to the river Esk (on your right hand

The Lynn near Rosslyn Castle, which was responsible for the name Rosslyn.

side). If you return to the bridge of the castle on the other side from where you started… you have missed it.

Roslin Glen

Roslin Glen is a protected site, as it is the largest surviving tract of ancient woodland in the area. Hundreds of species of flowering plants and sixty species of breeding birds have been recorded. The Glen was settled in the Bronze Age. Ogham script, an ancient Celtic alphabet, alongside a primitive carving known as the Diva, has been discovered in the Glen.The authors Baigent and Leigh describe it as a *"mysterious, seemingly haunted place. Carved into a large, moss-covered rock, a wild pagan head gazes at the passer-by."* They continue: *"Further downstream, in a cave behind a waterfall, there is what appears to be another huge head with cavernous eyes … The path leading through the valley is crossed by numerous ruined stone buildings and passes by a cliff-face with a dressed stone window. Behind this window is a veritable warren of*

tunnels, sufficient to conceal a substantial number of men and accessible only by a secret entrance: one had to be lowered down a well."

The Glen is far too big and these features too dispersed to find them all. It will need stamina and determination to track them all down. Some, like the Bronze Age inscriptions, are well-hidden under the undergrowth. They are intriguing, if you can discover them. Rather than the average, to-be-expected series of cup marks, there is a varied number of depictions, of spirals, concentric circles and other designs. They are all located on one large rock area, more or less on the opposite side of Wallace's Cave. There is no doubt that these are ancient, suggesting this area has been held sacred for many millennia before the arrival of the Sinclairs. On the one hand, this does favour the allegation made by some that there was once an important prehistoric artefact on the site of the chapel. On the other hand, however, perhaps it is more logical to suggest that over time, with the original site being in a difficult to get to, the site of the sanctuary shifted towards easier, more accessible ground, i.e. the general location of the present chapel.

Although these cup marks are ancient, the head described above is less certain. It looks less weathered and in general just too modern. Some even wonder whether the head lying in the midst of the foliage of the Glen is a copy done by an artist, taken from the depictions of the Green Man in the chapel.

Roslin Glen is also famous for the "Battle of Roslin", which occurred on 24th February, 1303. Eight thousand Scots defeated 30,000 English in three battles fought in just one day. It is believed that as the site was close to the Scottish headquarters of the Knights Templar, their prior, Abernethy, a retired knight in the Outremer, played a decisive role in the Scots' strategy, resulting in their victory. One of the bloodiest battles of its time, many soldiers died without unsheating their swords, being pushed over the cliffs of the glen. Fields such as Killburn, Shinbanes and Hewin are memories of the battle scene.

How to get there
Leaving the chapel, turn left on the main road and follow the signs left at the first crossing, which will take you down into the Glen. At the bottom is a car park.

An alternative, taking in a good portion of the Glen's beauty and giving some stunning views of the castle and the chapel, is described below. Between the visitors car park and the chapel, take the road down the hill, which reaches the cemetery. Walk along the path that bisects the old cemetery. After about a hundred metres, you will reach the castle.

In front of the castle gates, there are some steps leading down on the right-hand side. They will take you around the bottom of the castle. Walk through the arch of the bridge, and turn right on the path. Follow this path for some ten to twenty minutes (thirty if slow). At one point, it will descend towards the river. If the water is not too high, you can walk along the edge of the wall. Otherwise, it is best to return. Just beyond this "impasse", there are some railings on your left hand side. Just behind it, there is a crossing, with a path going up. This is a steep climb, which pensioners in good health can do at a leisurely pace, and it will lead you straight back to the chapel. Along this walk, you will see a gigantic waterfall (depending on the amount of rain), a small cave... and dozens of stunning sights, making you stand in awe of the geology of the Glen... and Nature in general.

Along this walk, you will see a gigantic waterfall (depending on the amount of rain), a small cave... and dozens of stunning sights, making you stand in awe of the geology of the Glen... and Nature in general.

Wallace Cave

Wallace Cave is named after William Wallace, who is believed to have taken refuge here. Inside, there are a number of smaller caves, forming the shape of a cross. Some have linked this cave with Gawain, a character from the Arthurian literature.

The cave is on the other side of the river (as seen from Rosslyn Castle). To reach it, you have to going through the river and climbing a steep cliff-face, or, alternatively, approach it from the other side of the river. It is situated near a field, next to a house, on the top of the road going out of the glen. At the end of the field, there is a set of steps, cut into the rock, leading to the cave.

The cave itself is a natural hollow that has been cut and shaped, and is approximately fifteen metres deep by five metres wide, opening out at the back. The doorway is approximately one metre wide and two metres tall. It is used by the local youngsters as a hangout.

9. THE CHAPEL AS THE TEMPLE OF SOLOMON

9.1 Stellar mythology and Rosslyn

The theme of the Temple of Solomon is frequently alluded to in the carvings at Rosslyn, if only in the inscription of the wine and truth, which is related to the rebuilding of the Temple. This connection is also what has made it so popular with Freemasons, whose own "Temple" is based on that design.

Various authors have argued recently that Rosslyn is either an accurate representation of the Temple of Solomon (Knight and Lomas) or a substitute for the Temple of Jerusalem (Laidler). They are, however, not the first. In his guidebook at the end of the 19th Century, Thompson often drew comparisons between the chapel and the Temple.

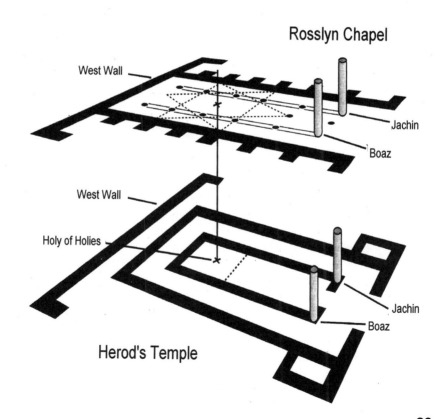

The design for the Temple of Solomon was a double square, and the same is true for Rosslyn Chapel, the centre being marked by the fourth pillar from the west. Knight and Lomas have overlain the ground plan of the Temple of Solomon with that of Rosslyn Chapel. In their layout, the Apprentice Pillar falls on the location of Boaz and the Master Pillar on that of Jachin. These are the central pillars that play an important role in the masonic ceremonies.

The legend goes that the knowledge of the antediluvian world, imparted to mankind by Shemhazai and his fellow Watchers, that is, the sciences, and more particularly, the arts and astronomy, had been inscribed by Enoch on two pillars. Freemasonic legends state that one of these pillars was later discovered by King Solomon when he built his Temple. This explains why the Temple is so important to the idealogy of Freemasons, for they believe that their temple incorporates this knowledge. The Temple of Solomon faced due East and in front of its Eastern entrance were two pillars. However, there is no entrance in the East of Rosslyn Chapel, unless one counts the entrance "from the underworld", from the crypt.

In mythology, the World Ash Tree connects earth to heaven, but it has also been erected on a square stone, the so-called foundation stone, which holds back the waters from the Abyss, or the Underworld. Intriguingly, the Apprentice Pillar stands immediately next to the "entrance to the underworld" of the chapel, the crypt.

The square, and by extension the cube (see also the "musical cubes" in the Lady Chapel), right next to the "abyss of the chapel" and the Apprentice Pillar, are linked to Saturn. In Greek mythology, according to Orpheus, the god Saturn, who was known to the Greeks as Chronos, was said to have dwelled amongst Mankind. In that respect, he resembles the "Watchers" and their leader, Shemhazai, also depicted in the Lady Chapel.

This square, the foundation stone, is often described as "a stone upon which rests a pillar that reaches from earth to heaven". Again, a reference to the Apprentice Pillar, which together with the other pillars, sustains the ceiling, one part of which is depicted literally as a starry heaven. It is said that when this foundation stone was removed from underneath the World Tree, the Flood or Deluge occurred. In Biblical mythology, the only person to survive this cataclysm was Noah. Mythology also links the foundation stone with Noah's Ark and, in Egyptian mythology, with the box/coffin of Osiris, which carried his body over the river Nile.

Before we get lost in these layers of symbolism, it should be made clear that the imagery used here is thousands of years old. Evidence of Mankind's religious preoccupation with these myths has been found as far back as Sumer, in the fourth millennium BC. From there - or from possibly another, even older source - it has trickled down into various cultures and civilisations and their myths: with the Jews in their Flood accounts, in Egypt with the story of the death of Osiris.

9.2 Rosslyn as a solar masonic temple

When Freemasonry announced its existence publicly in 1717, there were only three grades - and this has not changed. But other Freemasonic organisations have instituted "higher degrees", reserved for those, who were Master Masons, i.e. the third degree. One of these higher degrees is the Royal Arch, of which the Sinclair, who built the baptistery, was a grand master. Royal Arch Freemasonry came about in the middle of the 18th Century, although its origins are murky at best.

There has been quite an open astronomical connection to Freemasonry. Their two major feasts, those of John the Baptist and John the Divine, mark the summer and the winter solstices. The authors Knight and Lomas have underlined this connection. The initiate for the first degree is placed in the north-west corner, that of the summer solstice, marked by Jachin. Once the entered apprentice is to be put through the second degree, that of "fellowcraft mason", he "is placed in the south-east corner to 'mark the progress he has made in science'." It is the winter solstice marker, identified by Boaz.

In the third degree, the subject is death. To become a master mason, the fellowcraft mason is placed on the centre line of the temple, which is the East-West, equinoctial line, pointing to the vernal and autumnal equinox.
"The first part of the ritual takes places in the dark and its dramatic climax arrives with the candidate being symbolically murdered and laid 'lifeless' on the floor wrapped in a death shroud. The ritual continues in the darkness until a method is applied that allows the candidate to be raised from his 'tomb' and resurrected, to live once again. At that moment of resurrection, a light in the shape of a small five-pointed star is illuminated in the east, and the worshipful master draws the candidate's attention to the light of the 'bright morning star' that heralds his return to life."

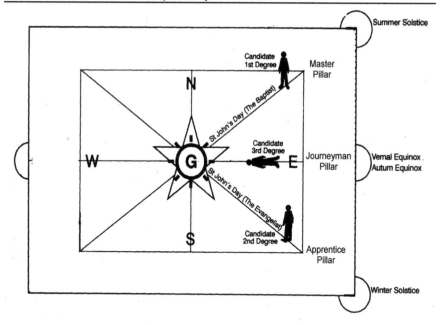

Intriguingly, in Rosslyn Chapel, these three positions are marked by the three "out of the ordinary" pillars: the Mason's, Journeyman and Apprentice Pillar, although in light of the above, they might be renamed Apprentice, Fellowcraft and Mason pillar. So perhaps it is here, in this mirroring, that the true significance of the legend of the murdered Apprentice can be perceived. If the Apprentice was indeed an apprentice, he had decorated the wrong pillar; and when the master mason returned, he noticed that the apprentice had decorated the master pillar, rather than the Apprentice Pillar.

It is in the Royal Arch degree that Knight and Lomas have seen certain parallels with depictions inside the Chapel. The rituals of that degree talk about permission to rebuild the Temple of Solomon, which occur in the story of King Darius, whose presence is inside the chapel.

It is in that degree that the "Name of God" is given to the initiates. It is this Name of God that was written on the square. Intriguingly, it is this "Name of God" that was given to Mankind,without authorisation, by Shemhazai. For this transgression God eventually sent the Flood... but to no permanent avail as, according to legend, that name had been carved on a pillar, which Solomon rediscovered when rebuilding his temple. He is believed to have incorporated it into the building's design,

being the same as the name that was written on the altar in the Holiest of Holies.

10. A ROSSLYN MERIDIAN?

Some researchers have suggested the possibility that Rosslyn was part of a larger complex. For example: should we look into the idea that Rosslyn might be connected to Roseline, a meridian that is believed to have been the nickname of the French Zero meridian? Should we read any significance into the presence of a gnomon on top of a gravestone in the cemetery?

Meridians were created for timekeeping. They served as local timekeepers at first. Until two centuries ago, most cities, towns and villages would set their own time by the sun. For this, they established a "local meridian". One often used technique was the gnomon, i.e. the sundial, which charts the shadow of the sun through the day to set the time and find the directions.

When the railways came, the companies needed to set their timetables using a single countrywide standard meridian which synchronised with local times. With Global trade becoming a normal feature of society, there was the need to set a single Zero meridian that the world could take as a standard by which time could be set. There were competing interests for the location of 0°, espcially with the French, who set their Zero Meridian, known as the Paris Meridian so that it passed through the greatest possible uninterrupted landmass in France, passing through Paris in the North and Carcassonne in the South. In the end it was at a conference in Washington, USA in 1884 that Greenwich was chosen, because of the overwhelming influence of the British Empire and its Navy.

Quite often the traces of these old meridian lines can still be seen, as is the case in Paris; and perhaps there is such a trace in Rosslyn also, although on a much smaller scale, of course, than in Paris. Are there any specific features north and south of Rosslyn that might indicate the presence of such a local meridian?

10.1 North

Exactly to the North is Arthur's Seat, the most famous geological feature of the Lothians. Arthur's Seat is an 800 ft. high extinct volcano, which erupted last some 350 million years ago.

Nearby stands Holyrood Abbey. In the "mythical origins" of the Sinclair dynasty, it is said that the Sinclairs were instrumental in building this abbey, named after the Holy Rood, supposedly a piece of the true cross of Christ, brought to Scotland by Princess Margaret under the

protection of a Sinclair. Although it is now known that this account is not accurate, several Sinclairs have been buried inside the Abbey. At least seven of the stones in the floor of Holyrood Abbey are memorials to Sinclairs, although most of them date from the 18th and 19th Century.

From Rosslyn Chapel, it is possible to see Arthur's Seat. Thanks to the presence of the canopy and its walkway, we are able to look over the new walls and buildings that would otherwise obscure the view... but which were absent when the chapel was erected. Most intriguingly, Arthur's Seat is visible as a twin-peaked mountain. Furthermore, it is the only mountain visible above the northern horizon. Imagine that there are no houses, and then Arthur's Seat could be seen to rise as the only hill above the northern horizon. Even today, in sunny weather, it is a magnificent view... though somewhat difficult to discover as one is distracted by the modern buildings.

Vincent Scully, a Yale University architectural historian, researched the sacred landscape of Crete and came to the following conclusions: all Minoan palaces were situated in an enclosed valley. There was a mounded or conical hill to the north or south of the palace and on its axis, a higher mountain, with a cleft summit or double-peak, further away on that axis. In fact, Scully's observations have since been found elsewhere in many cultures and in the "holy places" of Europe - though with variations. The themes are there, but the interplay of the various features is sometimes slightly different.

Notice how closely this works for Rosslyn. Rosslyn Castle is set inside an enclosed valley. For St. Matthew's Church, the original church, this was also the case. Rosslyn Chapel, however, has been set on top of a hill, which stands above the Castle.

Arthur's Seat is visible from Rosslyn Chapel, exactly to the North.

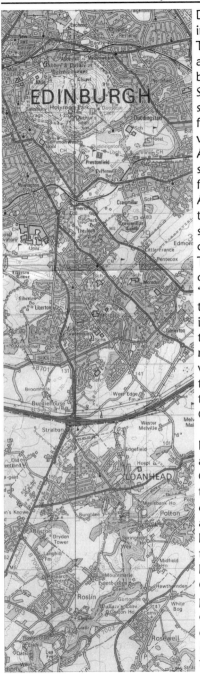

Directly north from the chapel, one can indeed see the twin-peaked Arthur's Seat. This has been linked to a pair of horns, raised arms or wings, the female cleft, or a pair of breasts. Furthermore, the fact that Arthur's Seat is volcanic in origin must have strengthened its mythological significance, for it is known that in ancient societies volcanoes were given sacred attributions.

Above Arthur's Seat, the Pole star would shine and it would be a natural focal point for anyone wishing to observe the stars. Anyone standing in Rosslyn Chapel, looking to the Arthur's Seat, would literally see the stars move around... rising in the East, setting over the Pentland Hills in the West.

The Northern polar stars have been described in many mythologies as the "everlasting stars". They were linked with the Afterlife. In many mythologies, including Celtic and Egyptian mythologies, the opening between a twin-peaked mountain was said to be the passage through which the souls of the deceased would enter the Afterlife. Can it be a coincidence that this age-old mythology is present in Rosslyn Chapel? Or was it by design?

Intriguingly, the connection between the Hill and Arthur's Seat was only made in the 15th Century, when the chapel was built. Before then, it was named differently. Arthur's constellation is the Great Bear, which circles around the pole star. To observe this, one has to look North. Therefore, to observe this feature above Arthur's Seat, one would have to be South of Arthur's Seat, with College Hill, where the chapel was built, a perfect location to make astronomical observations. So, as Arthur is the Great Bear circling around the Pole Star, which is visible (from Rosslyn Chapel) above Arthur's Seat, this could be one reason why the mountain

was renamed: it "anchored", or "sat" Arthur, who ruled the land.

In mythology, the Great Bear was said to be the chariot of the heavenly ruler, the pole star. But it was also considered to be the vehicle of the sun god, i.e. the sun.

North was linked to the World of the Dead. In some cultures, the sacred mountain to the north was sometimes called "Storehouse of the Dead". The twin-peaked hill between the temple and the "Everlasting Stars" of the North was thus considered to be a way-station to "Heaven". Perhaps the two peaks were compared to two "pillars", marking the entrance to the World of the Dead, where St. Peter greeted the dead with the key to heaven. And what about the two pillars of freemasonry?

10.2 South

Directly to the South is the impressively named "Mount Lothian". It is, however, "merely" a low hill. The hill is crowned by a grove of thirteen sycamore trees, the thirteenth being set off-centre. In the centre of the grove is the ruin of a 14th Century chapel, dedicated to St. Mary. Mount Lothian marked the western outpost or gate of Balentradoch, the Templar headquarters of Scotland. It was the location of a Cistercian abbey, to which the chapel belonged. The chapel is now in ruins, but once, it was the place where William Wallace was knighted - the scene made famous in the 1995 Academy Award winning movie "*Braveheart*".

Sycamores were often considered to be sacred trees. Their life-span is approximately 250 to 300 years, so the trees there now could not have been present during that knighthood. However, local farmers have

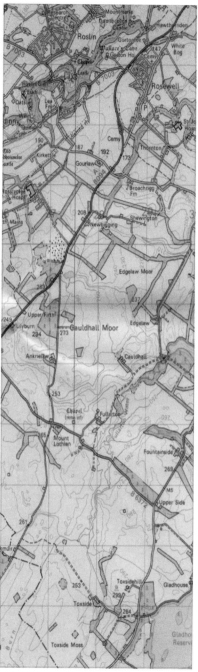

discovered tiling in the adjacent field, as well as debris of dwellings that make ploughing impossible. The name "Mount Lothian" also suggests it is an important place, the primary mountain for Lothian and therefore possibly the location from which the ruler of the Lothians ruled.

The legendary ruler of the Lothians was Lot. He was father of Gawain and his brothers, husband of Arthur's sister Anna (according to Geoffrey of Mommouth) or Margawse (according to Malory book II chapter XI). Geoffrey presents him as a supporter of Arthur, and already King of Lothian, whom Arthur placed on the throne of Norway - a country with connections to the Sinclairs when they acquired the Orkney Islands. The name Lot means "Lothian ruler" and therefore it is not a personal but a generic name. It seems certain that there was a king in the Lothian area in the 5th Century, but his headquarters appear to have been at Traprain Law, near Haddington, some thirty kilometres to the west of Edinburgh. However, maybe mythology had him rule from Mount Lothian, and as a result, this sacred place was later converted into a chapel. As Lot ruled the Lothians as a nation, the Scots looked upon William Wallace, at his knighthood, as the Guardian of Scotland, and looked to him to make free it from English rule.

Is it coincidence, or design? If by design, then the setting of Rosslyn Chapel within the landscape was a deliberate attempt by William St. Clair to make his kingdom a magical setting; a magic kingdom, very much like the concepts of Camelot and other Arthurian and Grail traditions with which William St. Clair must have been familiar. Furthermore, as we have seen, his teacher, Gilbert Hay, definitely knew about such legends, and stories about the Earthly Paradise, or the Garden of Eden.

11. THE CHAPEL AS THE MAGICAL GARDEN OF EDEN

Andrew Sinclair writes that after doing initial research on the chapel, *"exploring Rosslyn Chapel further, I found it a medieval stone herbal"*. As mentioned previously, books in the Middle Ages were called flower gardens or rosaria, arbours of roses. The flowers represented the search for wisdom and faith.

But could it be a magical garden? A "fairy garden"? There are four types of flowers on the ceiling; three of them have magical powers. Daisies are said to draw fairies, elves and nature spirits; lilies are the favourite plant of the nature spirits; the rose is said to hold the secret of time and its exploration. It is said that the fairies of this flower have strong ties to their elders, the angels, carved so abundantly along the windows of the church. They include their fallen leader, Shemhazai, who is hung by the rope that connected the "shaman", who was quite literally "a skywalker" and who travelled between heaven and earth, on his journey between both dimensions. The fourth type of flower, the sunflower, is linked to the sun. The fifth division of the ceiling is a starry sky, where the angels and the fairies will take you - the symbol of the Otherworld. To quote Paul Devereux: *"Access to these Otherworlds was by means of a conceptual axis [PC: also a meridian] that linked them - a World Tree, a Cosmic Mountain, [...] a rope or a ladder. By symbolically travelling in trance states along this axis, the Shaman could ascend to heaven or enter deeply into the body of the Earth, the Underworld. A mythological expression of this occurs in the Norse legend of the sovereign-shaman, Odin, who hung on Yggdrasil, the World Tree."*

The connection between heaven and Earth was therefore this Axis Mundi, the World Tree, the Djed-pillar of ancient Egypt, connected to their god Osiris. In all civilisations, at the foot of this World Tree were depictions of one or more serpent, encircling the Tree. The connection with the Apprentice Pillar is remarkable: it supports the ceiling, the "stone heaven" of the chapel, and stands next to the entrance to the crypt, the "underworld" of the chapel.

Devereux continues: *"The world axis, the axis mundi, is the omphalos, the centre, the point from which the sacred circle is struck, and from where the Four directions, the cardinal points, are marked, quartering the horizon."* In the landscape, this feature was Rosslyn Chapel itself, with the meridian being the first division of this "world circle". To conclude, Devereux writes: *"the shaman, then, entered the Otherworld by ascending and descending the World Tree [...]. The omphalos was the shaman's point of entry to the spirit world in trance."* Shamanism,

109

or "second sight", was also referred to by the authors Baigent and Leigh in their discussion of Rosslyn Chapel. Sir William St. Clair, who was Lord Justice General of Scotland under Queen Mary in 1559, was known to invite people, who are believed to have been gypsies, to stay around the Castle, where, during May and June, plays were performed. Two towers of the Castle, where the visitors stayed, were apparently nicknamed Robin Hood and Little John. The play had officially been banned by the Scottish Parliament on 20th June 1555, but it seems it was still performed at Rosslyn. Baigent and Leigh: *"Gypsies had, of course, long been credited with 'second sight'. Towards the beginning of the seventeenth century, this faculty became increasingly attributed to Freemasons as well."* They also show how Robin Hood was not so much an outlaw, but was pre-eminently *"a species of fairy derived ultimately from the old Celtic and Saxon fertility god or vegetation deity, the so-called 'Green Man', while in popular folklore Robin Hood was interchangeable with 'Green Robin', 'Robin of the Greenwood'."*

As Baigent and Leigh conclude: *"The Robin Hood legend provided, in effect, a handy guise whereby the fertility rites of ancient paganism were introduced back into the bosom of nominally Christian Britain. [...] Every May Day, there would be a festival of unabashedly pagan origin. Rituals would be enacted around the 'May Pole'."* This May Pole is known to have had its origins in the World Tree, the World Axis. So the Green Man was a handy disguise, as was the Temple of Solomon, for the latter was an omphalos, a navel of the world. There are references in the Bible (Jubilees 8 and Ezekiel) that connect the Temple with this navel. According to Jewish legend, *"this rock called in Hebrew Ebhen Shetiyyah, the Stone of foundation, was the first solid thing to be created, and was placed by God amidst the as yet boundless fluid of the primeval waters. Legend has it that just as the body of an embryo is built up in its mother's womb from its navel, so God built up the earth concentrically around this stone, the Navel of the Earth. And just as the body of the*

embryo receives its nourishment from the navel, so the whole earth too receives the waters that nourish it from this Navel."

So what is this World Tree-concept without its symbolic layer? Swiss anthropologist Jeremy Narby made a detailed study that concluded that shamanism, "second sight", is actually an ability, released by using certain hallucinogenic substances, to contact the "life force" resident within ourselves: DNA, the "building blocks" (foundation stone) of all life, from bacteria to plants to human beings, on Earth. He reiterates that *"I learned that in an endless number of myths, a gigantic and terrifying serpent, or a dragon, guards the axis of knowledge, which is represented in the form of a ladder (or a vine, a cord, a tree…). I also learned that (cosmic) serpents abound in the creation myths of the world and that they are not only at the origin of knowledge, but of life itself."* Narby's study, which is too complex to detail here, concludes that the vine and the ladder mimic the DNA spiral, which is literally a language, a code. Could it be this that is the "Name of God"? DNA seems far removed from the 15th Century, but the shamanic tradition is not. In the New World, one of the most potent hallucinogenic potions used by shamans is a drink called ayahuasca. The bark of the ayahuasca vine (*banisteriopsis caapi*) grows in thick double-helix shaped coils around rain forest trees, very much like the vine encircling the Apprentice Pillar.

Hallucinogenic plants allow a symbiosis with humans, offering them entry into another realm. One user, Daniel Pinchbeck, described the visions received from the usage of these plants: *"I looked into a swirling snake pit at the centre of my visual field, where serpents slithered and coiled around each other. The snake turned into a field where plants were growing at an incredible velocity, blossoming and then decaying, again and again and again. An endless profusion of botanical forms rose up, swooned, died, and rotted away."* This vision is similar to depictions in the chapel, specifically the Apprentice Pillar.

In Rosslyn Chapel, therefore, we have our garden. But why incorporate this knowledge in a church? Pinchbeck: *"There seemed to be a message to this - that a plant, like every living being, was actually made of energy, the form we see just a temporary snapshot, an illusory interruption of the constant flow, the movement of the spirit."* Where better than a church to talk about the spirit?

Perhaps even more intriguing is that the users of these hallucinogens also relate stories of the symbiosis between humans and plants and some even have visions of man and plants becoming one - as in the Green Man. And as in Pinchbeck's vision, the Green Man ages as he is depicted around the chapel's walls.

Is it possible that the inspiration for the decoration of Rosslyn Chapel came via hallucinogenic substances? Surprisingly the answer is that it may well be so. That Scotland knew and used hallucinogenic substances such as opium and ergot was shown during archaeological discoveries at Soutra. Soutra is located on the Roman "Dere Street", along the A68, south of Dalkeith and hence close to Rosslyn. Located on top of the prominent Memorial Aisle hill, the Lothians open up in front of you: from Bass Rock in the East to the Pentlands in the West.

Today, all that remains of this vast medieval hospital is Soutra Aisle, a small chapel-like structure, in the care of Historic Scotland. But in its heyday, from the 12th till the 17th Century, Soutra was run by the Augustinian order and its hospital was the biggest institution of its kind North of York. In 1460s, the king had taken away their lands, which had been their main source of income. This was the start of its gradual decline, as with no income, the hospital fell into disrepair. During the 17th Century, a new Trinity College was built on the site now occupied by Waverley Station, in the heart of Edinburgh. In the station, along the taxi rank between the main concourse and platform 7, is a plaque pointing out that the site once held a herb garden.

Since 1986, excavations at Soutra have been led by a local doctor Brian Moffat. They have provided a fascinating glimpse of medicines produced from herb seeds found at the site, including cannabis, opium and henbane - all hallucinogenic substances. They may have been grown for their medicinal qualities, but their hallucinogenic qualities were also known - and practised. Some have speculated that the resurgence of witchcraft in the Lothians in the 16th Century was directly related to the availability of these substances, as some of them are known to induce visions of "the Devil".

But before the 16th Century, when the middle classes were able to use these substances, William St. Clair was a local landowner, who might have been introduced to them earlier, and who might have decided to incorporate his visionary experiences in his chapel. If he did not, then it is still a remarkable coincidence that the "shamanic world" is so accurately captured by what can only be considered as St. Clair's bizarre choice in church decoration. So without the hallucinogenic explanation, the chapel remains a mystery. Accepting the hallucinogenic explanation explains the mystery.

If Rosslyn was all this, why? In most ancient civilisations where the traditions of the navel, the world tree, etc. are present, the king is believed to marry the land. In England, this idea still persists with the Stone of Destiny, upon which the English monarchs are crowned. Of

course, the Stone of Destiny was taken by King Edward when he raided Scotland. It was used in the coronation ceremonies of the Scottish kings, including Robert the Bruce. The coronation stone is a tradition that goes back to the dawn of time. Even today, Arthur's Seat is linked with the power of the king, the Scottish Parliament being situated in Holyrood Park, the park in which Arthur's Seat is located. King Arthur is no doubt the most powerful symbol of divine kingship.

Mount Lothian was where William Wallace was made protector of Scotland. It was a Celtic kingdom of Scotland that Robert the Bruce, Wallace's comrade in arms as well as his superior, tried to restore. Mount Lothian means: "the mountain of the ruler"; and the Sinclairs were the defenders of the Scottish monarchy and Scottish independence.

Paul Devereux has also discovered a connection between straight lines, such as a meridian, and kingship, tracing it back to the Indo-European word *reg, from which words such as right, correct, regal, etc. are derived. *"In such mystical union with the land, with the goddess, the king infused the earth with his power, the divine power only the kingly line [PC: an interesting phrasing of words] possessed."* Language scholar Eric Partridge explains *reg as "to set straight, to lead or guide straight, hence, as a noun, a true guide, hence a powerful one, hence a chief, a king." In this case, Arthur's Seat would be the Seat of the King, from which the magical king rules. Devereux and two other researchers discovered that in many cultures, these straight lines were associated with spirit travel - and also used for "shamanic travel", and thus become the "rope" between Earth and Heaven, the latter being the world of the Dead, which is the Northern sky.

Intriguingly, a recent analysis has also shown a possible translation of this word as "protector", as in the role the Sinclairs often took upon themselves to guarantee Scottish independence. To conclude, Devereux writes: *"So it seems possible that ritual and ceremonial straightness, marked by processions, ritual walking, boundary settings, straight ceremonial ways and landscape lines may in a few societies have been outward signs of an invisible, linear kingly force; symbolic of mystical rule."*

So where does that leave Rosslyn? Perhaps it leaves it with the builder, who was, indeed, a regent of many places in Scotland. Perhaps he tapped into this ancient symbolism and engineered it in its chapel, hoping to turn it into a new "power centre". Given the fame of Rosslyn and the importance attached to this, it seems he has - somehow - succeeded in this.

We all need a "sense of place", and for men of the likes of Sinclair,

"centring" their empire around Rosslyn was logical. It seems that the enduring legacy of this centring, in which esoteric knowledge was used, has resulted in making Rosslyn Chapel a centre-piece of modern esoteric thinking. Like an onion, every researcher will peel back more and more layers, until the complete message of the chapel is fully understood: a puzzle, made in stone, initiating the visitor into a frame of mind that is both extremely ancient... and extremely modern. Hence its continued appeal.

12. EXCURSIONS

12.1 Remains of the Temple Preceptory at Temple

Although it has been restored over the centuries, the church at Temple, roughly five miles from Rosslyn, is the only existing Templar property in Scotland. It is situated in a valley, next to the river. The Knights Templar first came to Scotland in 1128 during the reign of King David I, whom Hugues de Payens visited as part of his international recruitment drive. De Payens made a very favourable impression on King David, to the extent that he later surrounded himself by Templars and appointed them as "the Guardians of his morals by day and night". As a result of this Royal favour, through gifts from both the King and his Court, the Templars acquired a substantial property holding in Scotland. There were two major Preceptories at the time: in Midlothian, there was Ballantradoch, also known as Balintradoch or a number of other spellings, but now renamed Temple, which was regarded as the main Preceptory and the administrative headquarters of the Order in Scotland; the other was at Maryculter in Aberdeenshire, on the southern bank of the River Dee.

The centre at Temple was opened in 1129. It is alleged that Hugues de Payens was married to Catherine St. Clair, whose family had given the land to the order. However, there is no evidence for these allegations.

The Sinclairs were not present in the area at this time and it is known that Ballantrodoch was donated by King David I himself.

At the Battle of Falkirk, where King Edward defeated William Wallace, the king's archers stayed at Temple and were assisted by the Master of England and the Preceptor of Scotland. Edward's march to Falkirk had been under Templar command. But despite this allegiance to the English king, the Knights Templar suffered a similar fate to their French brethren.

When the Templars were rounded up in France in 1307, Scotland itself was not affected; but then the area south of the Firth of Forth, where Rosslyn is situated, belonged to England at that time. This fact is often neglected and it is frequently assumed that the Scottish borders were then as they are now, and that the Knights Templar of Temple were affected by the ban.

Upon receiving the Papal Decree, Edward ordered all Templars to surrender themselves at Holyrood Palace. Two Knights were arrested, Walter de Clifton and William de Middleton while a third, Thomas Tocci, surrendered voluntarily. None of them were of fighting age, or Scottish by birth, but all were residents of Temple, the Templars' Scottish headquarters. They were tried in 1308 by an ecclesiastical court, presided over by William de Lamberton, Bishop of St. Andrews. The Knights Templar were prosecuted by John Solario, the papal legate to Scotland. During the trials, both Henry St. Clair and his son William were called as witnesses. Researcher Mark Oxbrow points out that this evidence is at odds with the popular accounts, which state that the Sinclairs were the Knights' protectors. The evidence suggests nothing of the kind. In fact, the Sinclairs stated that they felt the Knights Templar were of no good, for *"if the Templars had been faithful Christians they would in no way have lost the Holy Land"*.

In spite of such testimony, which was after all merely the Sinclairs airing their personal prejudice against their neighbouring knights, the verdict was that the accusations were not proven and the Knights were released. Acceding to French pressure, in 1312 Edward did abolish the Templars in both England and Scotland. Any Scottish Templars under arrest were confined to the Cistercian Houses.

Two charters show that members of the Seton family, staunch Catholics and esteemed friends of the Sinclairs, were Masters of the Knights Hospitaller in 1346 and were in control of Temple. As in most countries, the Hospitallers were granted many of the former Templar lands, although North of the Firth of Forth, Robert the Bruce was reluctant to grant them that privilege.

Despite the fact that the ban did mean the end of Temple's association with Templars, one legend has it that treasure of the Knights Templar was removed secretly from Paris, to be hidden in Temple. A local legend states: *"Twixt the oak and the elm tree/You will find buried the millions free."* French legends about the Templar treasure apparently also state that the treasure was taken to Scotland, with the knights landing on the Isle of Mey, the first island they would encounter in the Firth of Forth. Geographically, this would take them to the mouth of the river Esk, which could take them on to Rosslyn – though this is theory, since seafaring ships would find it virtually impossible to reach that far inland. A route over land would definitely have been easier.

Only the outside walls of the church at Temple remain standing. In 1989, Dr. Crispen Phillips discovered a wall and a set of steps running north-south at right angles to the church. Subsequent excavations showed there was at least two feet of dressed stonework above the foundations revealing steps and the foot of a doorway.

On all four sides, it is surrounded by graves, many of which show the familiar "skull and bones"-motive. This design has been linked to masonic degrees, but in truth, the motive is quite common, and was a "memento mori": a reminder of death, expressing the knowledge we must all die eventually.

12.2 Abbotsford: the home of Sir Walter Scott

Abbotsford is the house that Sir Walter Scott built for himself. It is situated on the banks of the River Tweed and contains an impressive col-

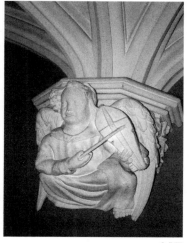

lection of relics, weapons and armours. It cannot come as a surprise that a writer of Scott's fame had a famous library, containing over nine thousand rare volumes. Scott's love for Rosslyn Chapel is expressed in one room, where carvings from the chapel have been reproduced. It should be stressed the room is not a replica of the chapel; instead, the decoration of the room is based upon the decoration of Rosslyn chapel.

How to get there
Two miles from Melrose, the Borders, take the A6091, heading North towards Galashiels. Turn left at the second roundabout, onto the B6360. Follow this road for 25 miles. On

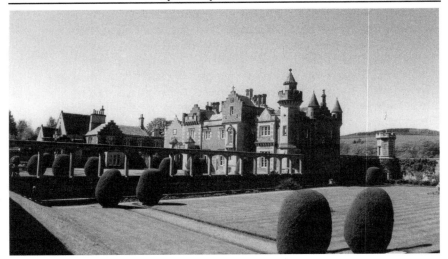

Abbotsford was a house specifically built for Sir Walter Scott. He ordered the architect to incorporate in one room, designs from Rosslyn Chapel.

the left is a car park opposite Abbotsford. Open mid-March to end of October. Closed on Sunday mornings except June-September. Information available from Abbotsford, Melrose, TD6 9BQ, Telephone 01896 752043.

12.3 Soutra Aisle: The destroyed hospital

Soutra Aisle is all that remains of the medieval hospital of Soutra. It is here that excavations have uncovered details of how medicine was practiced in one of the biggest and most famous hospitals in Europe. Situated along Dere Street, which connected Newcastle to Edinburgh (the route of the A68), it was a medieval highway, whereby the hospital functioned both as a hotel, first aid, spiritual retreat and hospital. Archaeological discoveries on the site have revealed the use of hallucinogenic substances, used during the treatment of patients, particularly as anaesthetics. The small remaining building is in itself not worthy of a visit, but the views from the Aisle over the Lothians, the Pentland Hills and the coasts of Fife are spectacular - weather permitting.

How to get there
It is situated along the A68, just South of Fala. From the Edinburgh direction, turn right where it is signposted. From the Lauder direction

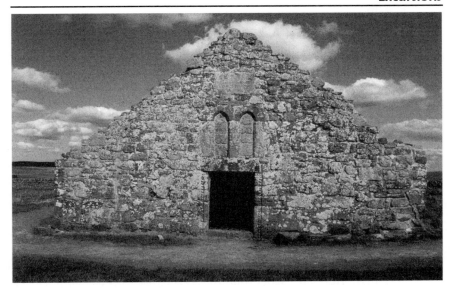

The only remnant from Soutra Hospital is so-called Soutra Aisle, a small religious building that can barely show the once splendour of the great hospital, even though its location still offers spectacular views.

(south), shortly after a long descent, turn left where it is signposted. Climb the hill, with signposts to Soutra Aisle and car park. The car park is about fifty metres beyond the Aisle and can take approximately eight cars. There is disabled access to this site.

12.4 Liberton's Balm Well: St Catherine's sacred well

Legend has it that a pilgrim let fall a drop of oil used to embalm St. Catherine of Alexandria that he was carrying to Queen Margaret from Mount Sinai. Where the drop fell, a spring welled up. There are coal deposits in the area and these are most likely linked to the water in the well which has an oily balm on its surface. This is a black tarry substance which was an effective ointment for some skin complaints and was also used to relieve the pain of sprains, burns and dislocations. As well as treating eczema, it was alleged that this well was used for treating leprosy, Robert the Bruce being one of its patients. This speculation is based on the assumption that Liberton is derived from "Leper-Town", but this is known to be incorrect. There is also no evidence to suggest that there was a leper colony near here or that lepers are connected with the well.

119

Because of its dedication to St. Catherine, one of the patron saints of the St. Clairs, it is believed they held this well in special reverence. Apart from the St. Clairs, this healing well was a place of pilgrimage for many Scottish monarchs. In 1504, James IV visited it and left an offering. In 1617, on a visit Scotland, James VI (and I of England) ordered that the well-house and steps be built, so that access to the balm was easier. In 1650 Cromwell's troops demolished the well. Over 200 year later, in 1889, the well-house was once again carefully rebuilt. Inscription belongs to Lord Prestonfield.

Originally a chapel to St. Catherine (known as St. Catherine of the Kaims) stood nearby. But in the early 19th Century, this was rebuilt as a house, and is now The Balm Well restaurant.

How to get there
From Roslin, follow the A701; cross the City Bypass at Straiton Junction. The Balm Well is situated on the A701, Howden Hall Road, opposite Mortonhall Crematorium. Streets in the immediate vicinity have Balm Well and St. Catherine's in their name.

13. APPENDIX: THEORIES ABOUT THE CHAPEL AND ITS SIGNIFICANCE

Chris Knight and Robert Lomas

In *The Hiram Key*, Christopher Knight and Robert Lomas, both Freemasons, set out to find the origins of freemasonry and believe they discovered them in a secret teaching of Jesus Christ and the original Jerusalem Church. The authors came to the controversial conclusion that the key rituals of modern Freemasonry were practised by the sect as a means of initiation into their community. Their analysis of ancient Egyptian records, the Old and New Testaments, early Christian and Rabbinical texts, the Dead Sea Scrolls and the rituals of Freemasonry, led them to reconstruct the lost story of Jesus and his brother James and describe their struggle to establish the "Kingdom of Heaven" upon Earth, using Masonic-style rituals. Their thesis is that the early Christians buried their most precious scrolls beneath Herod's temple shortly before they and the city were destroyed by the Romans in 70 AD. Lost to the world for over a millennium, they were clandestinely unearthed and interpreted by the Knights Templar, who adopted these ancient teachings and the rituals as their own. They believe these documents, the so-called scrolls of Jesus, are located in - or under - Rosslyn Chapel, which they consider to be a detailed reconstruction of the ruined temple of Herod. In their own words: *"The scrolls are not locked away in a vault. We believe that they are hidden deep below Rosslyn and the foundations of previous structures on the site. The scrolls are likely to be distributed in different places, in imitation of their concealment when they were originally placed under Herod's Temple nearly 2,000 years ago. When the Knights Templar excavated them between 1118 and 1128 AD, they will have recorded the location of each scroll. When William St. Clair built Rosslyn he would have followed these records as closely as possible."*

More recently, Knight and Lomas have explored the idea that William St. Clair is part of a long tradition of "Jewish priests", keeping sacred rituals that also form the backbone of Freemasonry, as described in the Qumran scrolls, some of which they are confident remain hidden in or under Rosslyn Chapel. They believe that William St. Clair started the building of the chapel in 1441 AD because the period of 1440 years is linked with a Venus-based calendar, which they have traced from biblical writings, in which the birth of Jesus and Moses leading his people out exile are other key dates.

Keith Laidler

In *The Head of God*, Laidler believes that the Knights Templar had a hidden tradition of the worship of sacred heads and that the lost treasure of the Templars is the head of Christ himself, which has been buried in Rosslyn Chapel. He believes that when the Knights Templar were arrested in 1307, only a few of their number were able to escape with their records and their artefacts. Laidler believes that amongst these treasures was a series of heads, the existence of which is supposedly recorded in the annals of the Inquisition. One of these heads was named Baphomet. Laidler tries to trace this head cult from the Egyptian Pharaohs, Samson and David, Solomon, Jesus, the medieval religious sect of the Cathars to Rosslyn Chapel, where one such head is supposedly hidden away.

Andrew and Niven Sinclair

There are two members of the Sinclair family who have voiced their opinion prominently on the chapel. Andrew Sinclair believes Rosslyn is the Grail chapel. He became inspired by a Templar grave with the depiction of a chalice containing the rosy cross and the crusading blade. He also believes that the so-called Kirkwall scroll depicts the secrets of the Knights Templar. This scroll is the property of a Masonic lodge in Kirkwall and is stored in an Orkney bank vault. The symbols are said to include a code that identifies the possible hiding place of the Grail as Rosslyn Chapel. Using carbon-dating, scientists estimated that the central panel dates from the 15th Century, when Rosslyn Chapel was built. Among the Templar and Masonic emblems on the cloth, Andrew Sinclair believes there is a ground plan of the Temple of Solomon, with two chambers containing the Ark of the Covenant and other relics. It is an exact match of the plan of Rosslyn Chapel.

Niven Sinclair believes that the lost Templar knowledge *"was encoded in the fabric of Rosslyn Chapel in order to pass it on to future generations. Earl William St. Clair built the chapel at a time when books could be burned and banned. He wanted to leave a message for posterity."* Niven Sinclair also believes that the Holy Rood is in Rosslyn Chapel. *"I had a copy of the 'Rood' made [which is currently on display inside Rosslyn Chapel]. It now appears as if it had always been there but the real 'Holy Rood' lies immediately beneath in the vaults. The three non-invasive scans which I have conducted of the vaults would tend to confirm the presence of the Holy Rood and of a statue of the Black Virgin - sacred to the Templars and to the Gypsies."*

Trevor Ravenscroft

Trevor Ravenscroft became famous with his book *The Spear of Destiny*, in which he argued that a spear allegedly used by a Roman soldier, Longinus, to pierce the side of Jesus while he was still hanging on the cross, was a talismanic tool that would give its possessor world control. Based on the testimony of Walter Johannes Stein, he believed Adolf Hitler had a vision when seeing this spear in Austria and that it added a magical dimension to the German Reich. Ravenscroft also nurtured a theory about Rosslyn Chapel, which he believed was an "Apocalypse in stone". He believed that together with Cintra in Portugal, there were seven sacred sites, situated along the pilgrim's route to Santiago de Compostella, in Spain. This idea was picked up and developed by Tim Wallace-Murphy, who wrote two guidebooks to the Chapel that relied heavily on the ideas developed by Ravenscroft. Ravenscroft, like Walter Johannes Stein, believed that inside the Apprentice Pillar was a jewelled chalice. Ravenscroft tried to have the pillar scanned, but permission was refused. So his wife chained herself to the pillar. Andrew Sinclair did scan the pillar some years later, but no evidence of gold or silver was found.

Karen Ralls-Macleod and Ian Robertson

The authors do not put forward a theory, so much as a possibility. They point out that according to Rosicrucian documents, the movement's mythical founder, Christian Rosencreutz, died in 1484. The location of his tomb was not revealed, although it is stated that it was inside a vault, with perpetual lamps and a mysterious book, "M". They point out that William St. Clair also died in 1484. Rosencreutz is said to have been a member of the Order of the Golden Fleece and many, including the authors, believe that William St. Clair was also a member. It was Sinclair biographer Hay who stated that he was, but in reality, as we have already noted, this was not so. However, according to Sir Walter Scott, William St. Clair was buried with a candle and a book, showing some parallels with the story of Christian Rosencreutz. An intriguing coincidence, which is as much as the authors dare to point out.

14. BIBLIOGRAPHY

1421. The Year China Discovered the World. Gavin Menzies. London: Bantam Press, 2002.

An Account of the Chapel of Roslin 1778. (original from 1774, by Dr. Robert Forbes, Episcopalian Bishop of Caithness.) Reprinted by Grand Lodge of Scotland, Edinburgh, 2000.

An Illustrated Guide-Book to Rosslyn Chapel. Tim Wallace-Murphy. Roslin: The Friends of Rosslyn, 1993.

Black Spark, White Fire. Did African Explorers Civilize Ancient Europe? Richard Poe. Prima Publishing, 1997.

Breaking Open the Head. Daniel Pinchbeck. London: Broadway Books, 2002.

Double Standards. The Rudolf Hess Cover-Up. Lynn Picknett, Clive Prince and Stephen Prior. London: Little, Brown and Company, 2001.

Earl Henry Sinclair's fictitious trip to America. Brian Smith. New Orkney Antiquarian Journal, vol. 2, 2002.

Holy Grail Across the Atlantic. The Secret History of Canadian Discovery and Exploration. Michael Bradley, with Deanna Theilmann-Bean. Willowdale, Ontario, Canada: Hounslow Press, 1988.

In Search of the Holy Grail and the Precious Blood. Ean and Deike Begg. London: Thorsons, 1995.

Mary. Queen of Scots. Antonia Fraser. London: Weidenfeld & Nicolson, 1969.

Muirfield and the Honourable Company. George Pottinger. Edinburgh and London: Scottish Academic Press, 1972.

Rosslyn – A History. The Guilds, The Masons and the Rosy Cross. Robert Brydon. Roslin: Rosslyn Chapel Trust, 1994.

Rosslyn Chapel. The Earl of Rosslyn. Roslin: Rosslyn Chapel Trust, 1997.

Rosslyn Chapel and hinterland: The Landscape of Midlothian. Jacqui Queally. Edinburgh: Celtic Trails Scotland, 2003.

Rosslyn. Country of Painter and Poet. Helen Rosslyn & Angelo Maggi. Edinburgh: National Gallery of Scotland, 2002.

Rosslyn. Guardian of the Secrets of the Holy Grail. Tim Wallace-Murphy and Marilyn Hopkins. Shaftsbury, Dorset: Element, 2000.

Rosslyn. Its Castle, Chapel and scenic lore. Will Grant. Kirkcaldy: Dysart & Rosslyn Estates.

Shamanism and the Mystery Lines. Ley Lines, Spirit Paths, Shape-Shifting and Out-of-Body Travel. Paul Devereux. London: Quantum, 1992.

Symbolic Landscapes. The Dreamtime Earth and Avebury's Open Secrets. Paul Devereux. Glastonbury: Gothic Image Publications, 1992.

The 'Bleeding Angel' In the Crypt of Rosslyn Chapel. Ward L. Ginn, Jr.. Saunière Society Newsletter.

The Cosmic Serpent. DNA and the Origins of Knowledge. Jeremy Narby. New York: Jeremy P. Tarcher/Putnam, 1998.

The Discovery of the Grail. Andrew Sinclair. London: Arrow Books, 1998.

The Freemasons. Jasper Ridley. London: Robinson, 2000.

The Head of God. The Lost Treasure of the Templars. Keith Laidler. London: Orion, 1998.

The Hiram Key. Pharaohs, Freemasons and the discovery of the secret scrolls of Jesus. Christopher Knight and Robert Lomas. London: Arrow Books, 1997.

The Holy Blood and the Holy Grail. Michael Baigent, Richard Leigh and Henry Lincoln. London: Corgi Books, 1994.

The Holy Grail. Its Origins, Secrets and Meaning Revealed. Malcolm Godwin. New York: Viking Studio Books, 1994.

The Illustrated Guide to Rosslyn Chapel and Castle, Hawthornden, &c.,

The Rev John Thompson. Edinburgh: St Giles' Printing Company and London: J. Menzies & Co., 1892.

The Invisible College. The Royal Society, Freemasonry and the birth of Modern Science. Robert Lomas. London: Headline, 2002.

The Occult Roots of Nazism. Secret Aryan Cults and their influence on Nazi ideology. Nicholas Goodrick-Clarke. New York: NYU Press, 1992.

The Origins of Freemasonry. Scotland's Century, 1590-1710. David Stevenson. Cambridge: Cambridge University Press, 1988.

The Quest for the Celtic Key. Karen Ralls-Macleod and Ian Robertson. Edinburgh: Luath Press, 2002.

The Second Messiah. Templars, the Turin Shroud and the Great Secret of Freemasonry. Christopher Knight and Robert Lomas. London: Century, 1997.

The Secret Scroll. Andrew Sinclair. London: Sinclair-Stevenson, 2001.

The Sword and the Grail. The Story of the Grail, the Templars and the true discovery of America. Andrew Sinclair. London: Century, 1993.

The Templar Legacy and the Masonic Inheritance within Rosslyn Chapel. Tim Wallace-Murphy. Roslin: Friends of Rosslyn, 1994.

The Templar Revelation. Secret Guardians of the true identity of Christ. Lynn Picknett and Clive Prince. London: Bantam Press, 1997.

The Temple and the Lodge. Michael Baigent and Richard Leigh. London: Corgi, 1997.

Uriel's Machine. The Ancient Origins of Science. Christopher Knight and Robert Lomas. London: Arrow Books, 2000.

15. HOW TO GET TO ROSSLYN CHAPEL

Roslin is located just off Edinburgh's City Bypass, south of Loanhead and east of Penicuik. On the City Bypass, take the Straiton Junction exit to the A701, to Peebles and Penicuik. Go past the superstore Ikea, and Roslin is sign-posted to the left. Once in Roslin, the chapel is signposted, but you need to look for it. Where the road makes a sharp bend to the right, you can see a smaller road ahead, going down and then up again. That is the road leading to the chapel. There is parking in front of the visitors' centre and a visitors' car park next to the old Rosslyn Inn, some fifty yards away from the chapel.

There is a bus service from Princes Street, in the centre of Edinburgh, to Roslin. The railway that brought visitors to the chapel a century ago has since disappeared.

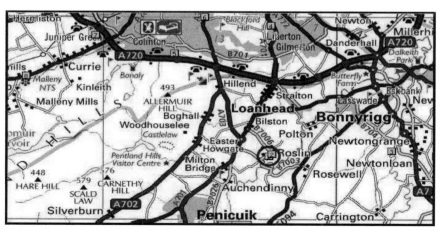

16. INFORMATION

The chapel, its shop and tearoom are open all year, 10.00 am to 5.00 pm (Sundays 12.00 pm to 4.45 pm). There is an admission charge with discounts for groups of more than twenty. Guides are available, and visits out of the opening hours can be arranged. A church service is held each Sunday at 10.30 am.

The Rosslyn Chapel Association can be joined for a yearly fee, which entitles members to free entry to the chapel plus a newsletter.

Rosslyn Chapel Association, Rosslyn Chapel, Roslin, Midlothian, EH25 9PU, Scotland, United Kingdom
Phone: 0131-440 2159
Fax: 0131-440 1979
Email: rosslynch@aol.com
Website: www.rosslynchapel.org.uk

1. St. Clair gravestone
2. Caithness memorial
3. Lovers and Devil
4. Agnus Dei
5. Robert the Bruce death mask
6. Faces
7. Green Man
8. Shemhazai
9. Dance Macabre
10. Virgin and Child
11. Master pillar
12. Journeyman pillar
13. Apprentice pillar
14. William St. Clair depiction
15. Heads
16. Wine inscription
17. Knight Leslyn
18. Vault entrance
19. William St. Clair tomb
20. Knight and Lomas initiate

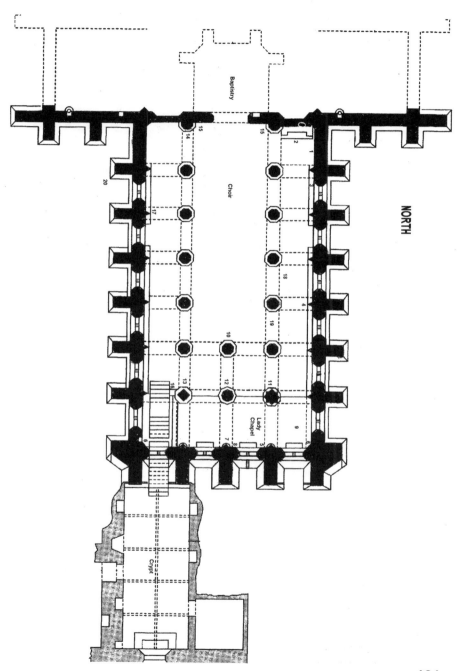

DARWIN'S MISTAKE

Dr Hans Zillmer

Yes, there were cataclysms (among them The Flood) in the course of history, but no, there was no evolution. The Earth's crust is relatively young and no more than a few thousand years ago; its poles were free of ice.

Published in nine languages, this international bestseller puts the latest discoveries and new evidence against Darwin's Theory of Evolution. The author, who owes his insights and expertise to numerous excavations he participated in, describes recent findings that – in line with suppressed results of scientific research – prove what seems unthinkable to us today: Darwin was wrong.

*120 Pages. Paperback. Euro 25,90 * GBP 14.99 * USD $ 19.95. Code: DMIS*

SAUNIERE'S MODEL

André Douzet

After years of research, André Douzet discovered a model ordered by abbé Bérenger Saunière. Douzet reveals that Saunière spent large amounts of time and money in the city of Lyons... trips he went on in the utmost secrecy. Douzet finally unveils the location indicated on the model, the location of Saunière's secret.

*116 Pages. Paperback. Euro 14,90 * GBP 7.99 * USD $ 12.00. Code: SMOD*

CROP CIRCLES, GODS AND THEIR SECRETS

Robert J. Boerman

For more than 20 years, all over the world, mankind has been treated to thousands of crop circle formations, and until now, nobody has been able to explain this phenomenon. In this book, besides a scientific and historical section, you can read how the author links two separate crop circles. They contain an old Hebrew inscription and the so-called Double Helix, revealing the name of the 'maker', his message, important facts and the summary of human history. Once he had achieved this, he was able to begin cracking the crop circle code.

*159 Pages. Paperback. Euro 15,90 * GBP 9.99 * USD $ 14.00. Code: CCGS*

THE TEMPLARS' LEGACY IN MONTREAL, THE NEW JERUSALEM

Francine Bernier

Montréal, Canada. Designed in the 17th Century as the New Jerusalem of the Christian world, the island of Montreal became the new headquarters of a group of mystics that wanted to live as the flawless Primitive Church of Jesus. But why could they not do that in the Old World? The people behind the scene in turning this dream into reality were the Société de Notre-Dame, half of whose members were in the elusive Compagnie du Saint-Sacrement. Like their Templar predecessors, they worked for humanity and aimed to establish an ideal social Christian order. Montréal's destiny was to become the refuge of the most virtuous men and women who expected the return of a divine king-priest; a story connected with the mystery of Rennes-le-Château, and the revival of a heterodox group whose marks, and those of the French masonic Compagnons, are still visible today, both in the old Montréal city... and underneath.

*360 pages. Paperback. GBP 14.99 * USD $21.95 * Euro 25.00. code: TLIM*

NOSTRADAMUS AND THE LOST TEMPLAR LEGACY

Rudy Cambier

Nostradamus' Prophecies were *not* written in ca. 1550 by the French "visionary" Michel de Nostradame. Instead, they were composed between 1323 and 1328 by a Cistercian monk, Yves de Lessines, prior of the Cistercian abbey of Cambron, on the border between France and Belgium. They reveal the location of a Templar treasure. Nostradamus' "prophecies" has shown that the language of those verses does not belong in the 16th Century, nor in Nostradamus' region. The language spoken in the verses belongs to the medieval times of the 14th Century, and the Belgian borders, not the French Provence in the 16th Century. " The location identified in the documents has since been shown to indeed contain what Yves de Lessines said they would contain: barrels with gold, silver and documents.

*192 pages. Paperback. USD $ 17,95 * GBP 11,99 * Euro 22.90. code: NLTL*

Write for our free catalog of other fascinating books, videos & magazines.

Frontier Sciences Foundation
P.O. Box 48
1600 AA Enkhuizen
the Netherlands
Tel : +31-(0)228-324076
Fax : +31-(0)228-312081
email : info@fsf.nl

website : www.fsf.nl

Adventures Unlimited
P.O. Box 74
Kempton, Illinois 60946
USA
Tel : 815-253-6390
Fax : 815-253-6300
email :
auphq@frontiernet.net

website :
www.adventuresunlimitedpress.com